D1396509

PAINTING CHILDREN

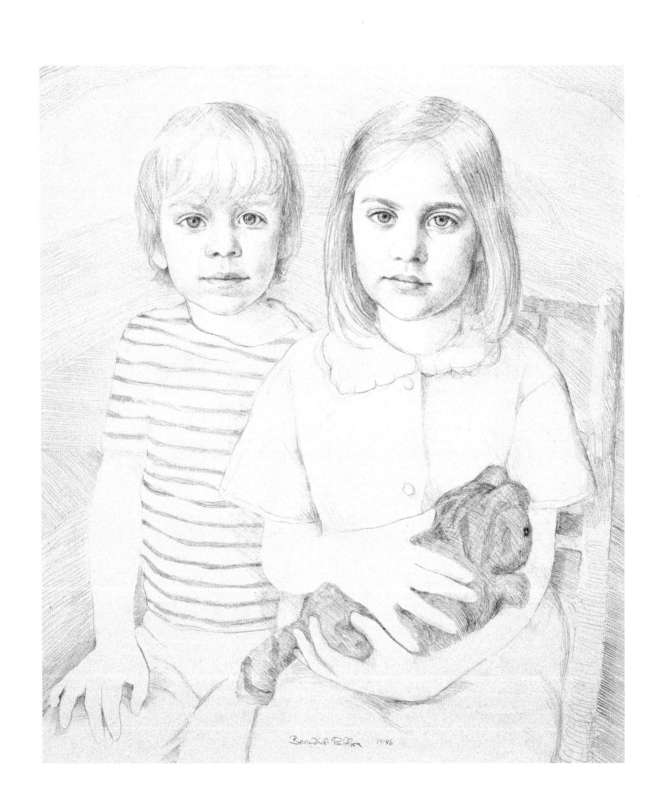

Benedict Rubbra 1986

BENEDICT RUBBRA

PAINTING
CHILDREN

WATSON-GUPTILL PUBLICATIONS/NEW YORK

First published in 1993 in the United States
by Watson-Guptill Publications,
a division of BPI Communications, Inc.,
1515 Broadway, New York, N.Y. 10036

First published in 1993 in Great Britain by
The Herbert Press Ltd, 46 Northchurch Road, London N1 4EJ

Library of Congress Cataloging-in-Publication Data

Rubbra, Benedict.
 Painting children / Benedict Rubbra.
 p. cm.
 Includes index.
 ISBN 0–8230–3593–X
 1. Portrait painting—Technique. 2. Children—Portraits.
 I. Title.
 ND1329.3.C45R82 1993
 751.4—dc20 92–25386
 CIP

Set in Aldus

Typeset by Nene Phototypesetters Ltd, Northampton

Printed and bound in Hong Kong
by South China Printing Company (1988) Ltd

Manufactured in Hong Kong

First printing, 1993

1 2 3 4 5 6 7 8 9 10/97 96 95 94 93

CONTENTS

FOR TOBIAS AND TABITHA
WITH LOVE

ACKNOWLEDGEMENTS

I would like to thank all the children who have sat for me and whose portraits are represented in this book:

Lincoln Ainge	Zeb Gourlay	Martin Phipps
Claire Buckley	Mathew Greenham	Ben Pilling
Adriano Castoro	Thomas Greenham	Thomas Pilling
Nicholas Castoro	Mary Hall	Max Porter
Katherine Cowan	Thomas Hall	Roly Porter
Ruth Cowan	Rachel Hopkin	Christopher Record
Marnie Dickens	Daisy Hutchison	Robert Record
Charles Dornton	Jeremy Hutchison	Thomas Richards
Angus Fletcher	Jacob Kelly	Anna Ricketts
Edward Fletcher	Rachel Kelly	Stefan Ricketts
Henry Fletcher	Toby Kelly	Celia Rosenwald
Kate Fowler	Anna Kenyon	Tabitha Rubbra
Camilla Gavin	Tom Kenyon	Toby Rubbra
Juliet Gomperts	Barnaby King	Judy Slater
Miranda Gomperts	Charlotte King	Tatty Theo
Natasha Gomperts	Daniel King	James Tidmarsh
Alice Goodhart	Alex Lenko	John Tidmarsh
Alastair Gourlay	Katie Lenko	The Colin Davis Family
Justin Gourlay	Nicholas Lewin	The Holberton Family

INTRODUCTION

Painting children is a special and very enjoyable kind of portrait painting which demands its own special skills. The aim of this book is to help the reader master these skills and to solve the problems that arise.

Chapter 1 contains advice on materials and different media and how to use them. I have assumed that you will already have had some instruction and practice in the rudiments of drawing and painting techniques, but I hope that beginners as well as those with more experience will find my suggestions encouraging and a spur to success.

The more you learn to use your eyes to search out shapes and relationships in your subject, the more exciting and rewarding painting becomes. As your skills increase, so your confidence grows, and new techniques can be explored. Most important of all, this growing confidence will encourage you to perfect the ability to choose or select the colours and shapes you want to put in or leave out, thus giving the painting your own distinctive style. The text and illustrations in this book are not meant to show everyone who reads it how to paint an identical portrait. My aim is to guide you through some fundamental ideas and techniques directly related to painting children, so that ultimately you will find your own particular way of painting.

The three essential ingredients needed in a successful child portrait are spontaneity, freshness and brightness. Your task as a painter is to discover techniques that will help you to capture these fundamental qualities and make the art of child portraiture distinctive and exciting.

'Spontaneity', when related to children, means natural or unforced. It is an attractive quality and is central to the character of a young child. I have tried to focus my advice on discovering how to paint with corresponding directness and spontaneity.

The painter's eye takes in a mass of information that has to be sifted and organized. Shapes have to be understood, and colours and lines related, before it is possible to translate what you see onto a flat canvas or piece of paper. When you are painting a still life, the eye can absorb and the mind can structure this information at leisure; the subject remains stationary. Painting children is different. The eye and the mind have to interpret forms and colours that are constantly moving, and there is therefore an urgency of purpose with little time to ponder. Decisions have to be made with speed.

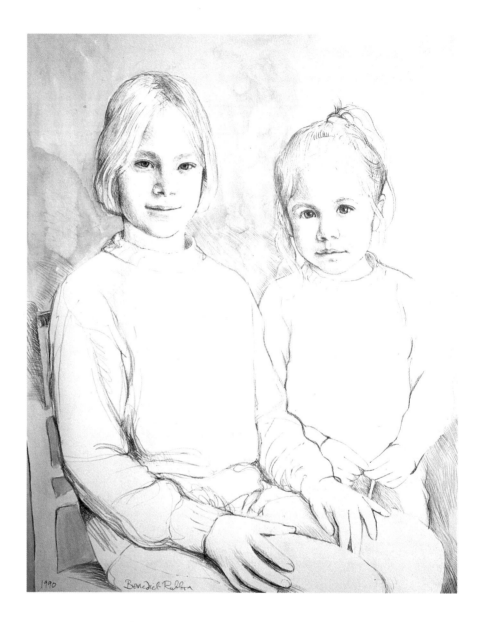

1990 Benedick Rubbra

The exercises at the beginning of the book are intended to help you develop a skill in quick understanding and are relevant both to the beginner and to the more advanced student. (Even the most skilled concert performer has to practice his scales and arpeggios if he is to give a lively performance.) These exercises are fundamental to the general techniques of seeing and painting but are even more important in the specialized art of child portraiture.

The second vital ingredient, freshness, is gained by learning appropriate techniques of applying the paint or moving the pencil. A likeness can be captured by correct drawing, but it will be the freshness of pure colours and tones that expresses the spirit of the child. Develop your skill in

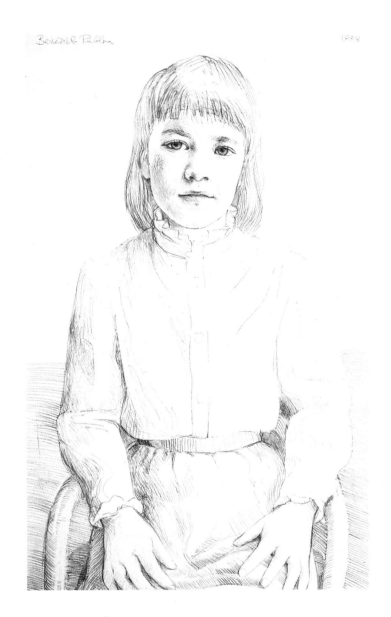

selecting a simple palette of three or four colours and discover the many
exciting ways in which these colours can be applied. You must learn also
to express the idea of freshness through a feeling of movement in the pose
– the turn of the head in relation to the line of the shoulder, the position
of the hands, and the subtle twists and turns of the body. A child's
character is expressed through the movement of the body as well as
through fleeting and changing facial expressions, and the ultimate success
of your portrait depends on how these transient movements can be caught
with fluency and freshness.

The third ingredient, brightness, is centred in the face and particularly
in the expression in the eyes. In chapter 3, I explain what you should look

for when painting or drawing the features. Each feature is dealt with independently and analytically. If you understand the structure of a form and how it 'works', as you look at it, you will be able to draw with confidence and therefore with greater freedom. A good likeness also depends on drawing the shapes and forms *between* the features, and these, too, need to be carefully observed.

When you have fixed correctly the features and the relationships between them, you can add brightness to your portrait by fine adjustments in the expression. Painting expression is like painting the waves and ripples in water: the shapes are elusive and difficult to assess – as soon as you think you have seen a shape it changes into another, but somehow the form of the water remains constant. For example, subtle variations within the form of the mouth occur as the expression changes from sadness to happiness. These shifts are also difficult to assess and record but the basic form, like the water, remains constant. The form must be fully understood before these elusive variations within it can be expressed.

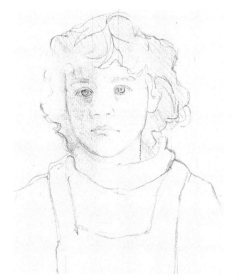

The attitude and response of the artist to the sitter is no less important than the skill of seeing and selecting. The length of time for each session must be carefully judged according to the age and temperament of your sitter. Try to establish a good working relationship. Perhaps the child could do a drawing of you or could help you squeeze out the paints. Occasionally you will have to succumb quietly to awkward behaviour. This can be frustrating, but it is important to avoid hostilities. Tact and endless patience are often required and can be stretched to their limits, as mine were a little while ago. I was asked to do a drawing of two young children who were to sit together. The elder girl was co-operative and I was able to decide on the pose, but then work was held up because her little sister absolutely refused to sit in front of me. The second and third sessions were taken up with gentle coaxing and stories read over and over again by her father. Momentarily she relented – I was allowed to draw the back of her head. I had to keep calm or everything would have been lost. Finally (and by now my bagful of tricks that I use to coax a glance was nearly used up), I managed a quick sketch that she recognized as herself, and instantly she understood why she had to sit still. The problem now was that she tried so hard not to move that her body stiffened, her mouth set into a tight line and her breath was held in – which was worse than before! However, in the end I did manage to get her to relax so that I could finish the drawing.

1 · MATERIALS AND TECHNIQUES

PENCIL

The pencil is your basic tool and there should always be one in your pocket or within easy reach. It can be used to make detailed studies, to jot down ideas, or to create finished portraits; to suggest youthful movement by describing continuous flowing lines, or, used tonally, to describe soft rounded forms. Try to sense a chord of communication between the tip of the pencil and your eyes. Imagine your pencil following the contours (the curves and changes in direction) of the form.

Relate the type of pencil you use to the type of paper. A soft pencil on rough paper will produce a very different effect from a hard pencil on hard, smooth paper. After some experimentation, try to select a combination of paper and pencil that you think would be appropriate to the character of the child you are going to draw.

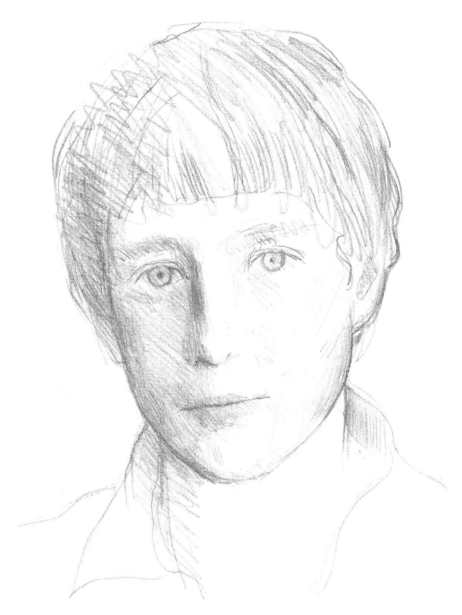

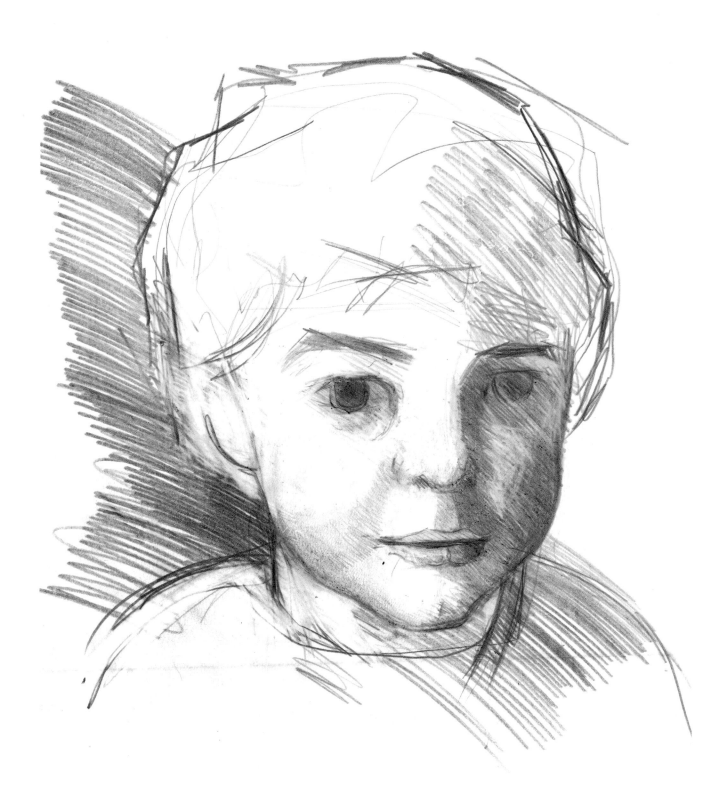

The pencil is very useful for making studies that will form the basis of a painting. First make a study of the head, concentrating your eye on the main form of the head and the shapes of different areas of tone within the face.

Place a sheet of tracing paper over the drawing. With a fine pencil or pen, trace over the outline. Make adjustments to the contours and position of the features where necessary. Turn the tracing over (this has the same effect as looking at your drawing in a mirror, and any discrepancies in the drawing will be shown up). You can now transfer your tracing onto a canvas by squaring it up (see page 86 – you could make it proportionately bigger or smaller). Or, if the size is to remain the same, you can use the tracing to place over the painting as you proceed. This is a simple method of checking that you have correctly positioned the features or the line of the contour.

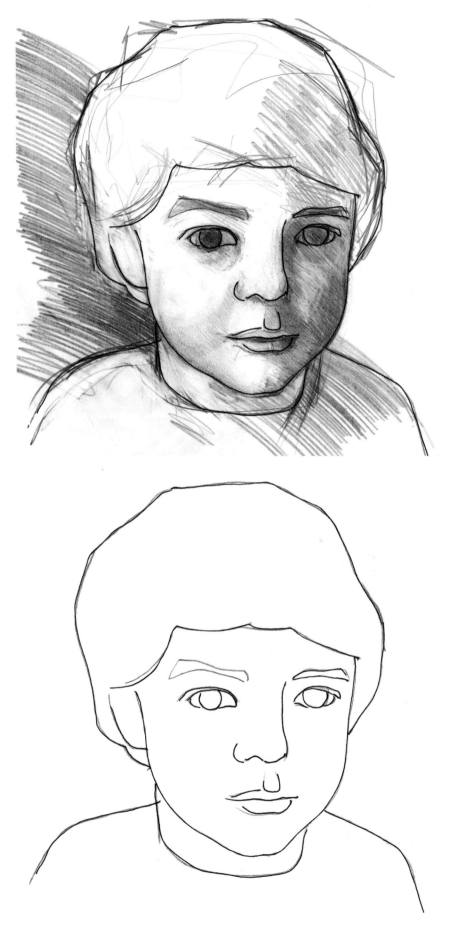

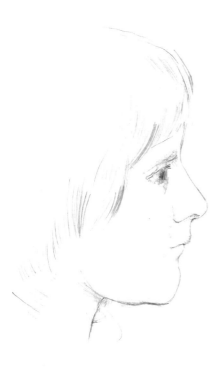

Find out what you can do with different types of pencil. A hard one could be used to explore fineness of contour or intricate shapes and patterns, a medium pencil to exploit line, and a soft pencil to construct solid forms.

Study the way the slightest accentuation of line can change an expression; for instance, an emphasis in the corner of the eye or the line of the mouth.

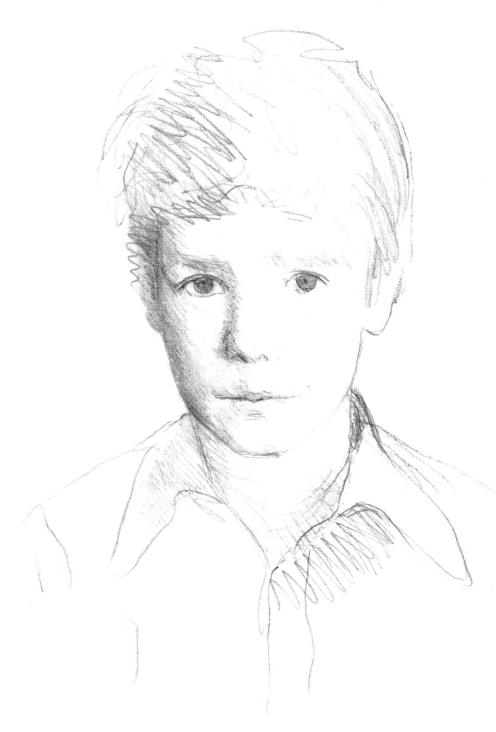

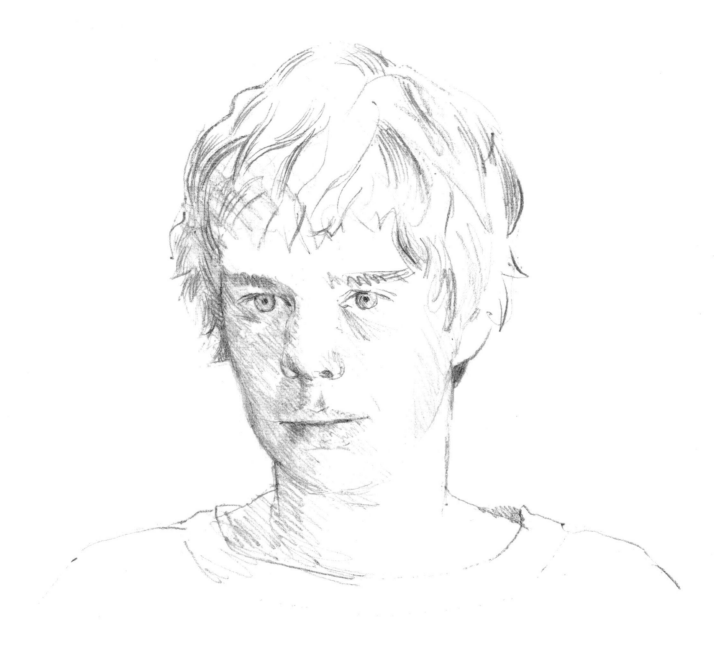

CHARCOAL

Charcoal is ideally suited for tonal drawing but fine lines and detail can also be achieved.

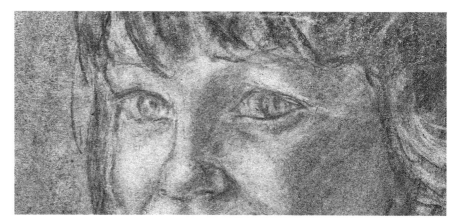

Experiment with lines of different character and on different papers.

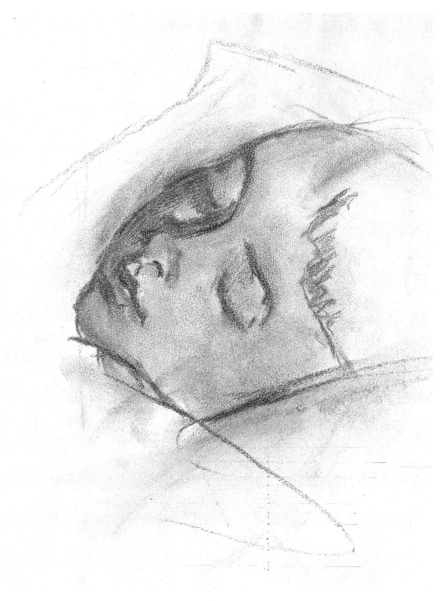

The real excitement comes when you build up the form with bold sweeps and strong contrasting tones. Highlights can be suggested by using an eraser, and forms can be softened by smudging with your finger. Look at the different textures between the cheek and the hair in the drawing opposite.

When finished, charcoal drawings should be sprayed with fixative to prevent smudging.

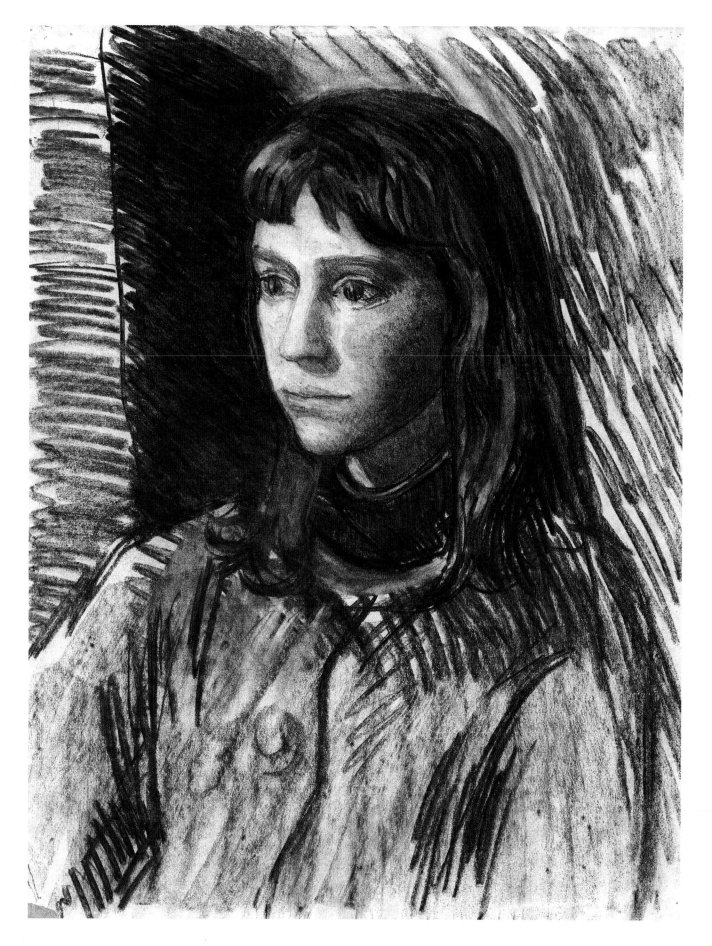

PENCIL WITH TURPENTINE

Stretch a sheet of paper as you would for a watercolour: soak the paper in water, allow the excess water to run off and lay the paper on a drawing board, tape down the edges with paper tape, and leave it to dry. When the paper is dry, coat it with rabbit-skin size – or with wallpaper paste – and again let it dry. This treatment will prevent the turpentine from soaking into the paper.

Using a soft pencil (3B or 4B), scribble over an area of your paper and then paint over this with a brush dipped in turpentine (or a turps substitute – which is less sticky and often better for this technique). You will find that the pencil dissolves into a wash. Try out different textures, using a rag – or even your thumb.

Re-draw over the wash with pencil. Lighten tones by painting with clean turps and then dabbing off with a rag.

This technique is very useful for quick sketches or preliminary studies. If a mistake is made, then all you have to do is wipe over the drawing with a rag soaked in turps. It is also a technique that will encourage you to draw freely and is good both as a loosening-up exercise and a halfway house between drawing and painting.

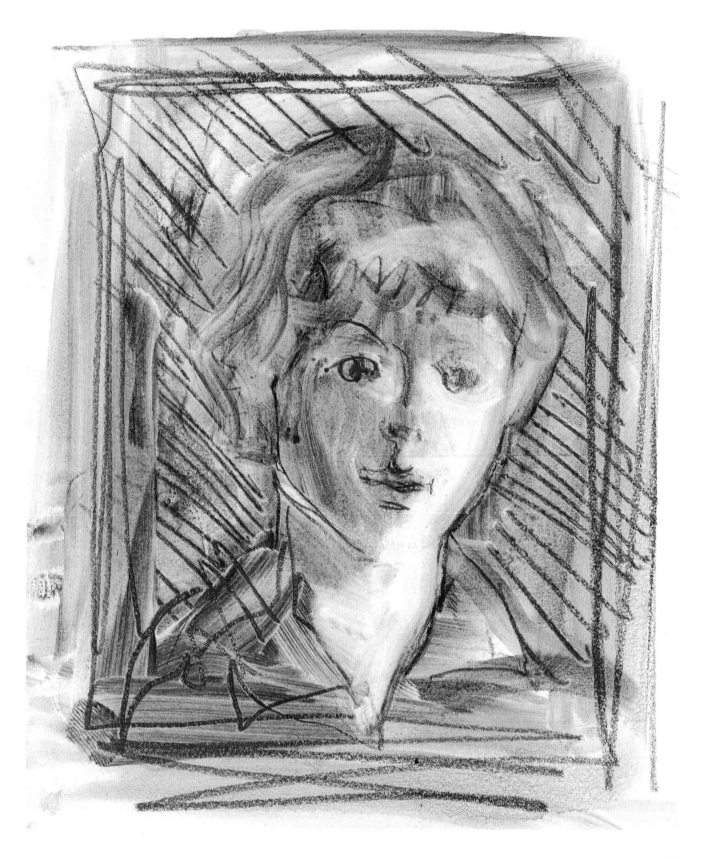

WATERCOLOUR

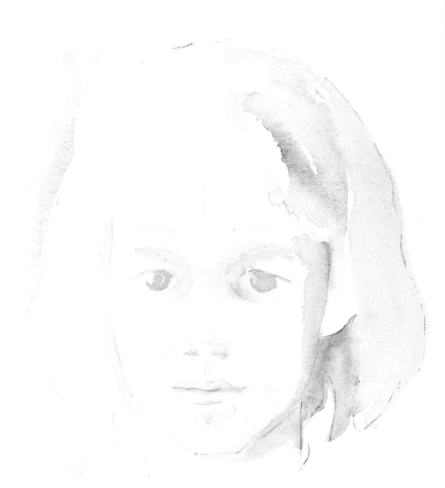

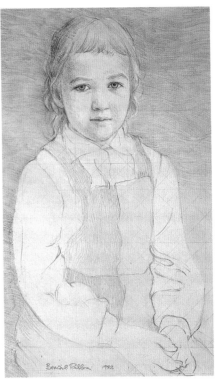

Try using pencil over a watercolour wash on a rough-surfaced paper.

Watercolour, as a medium and technique in its purest form, is ideal for expressing qualities such as transience (the changing light in an English landscape for example) or impressions of radiance or softness like those given by a child's skin. Forms, colours and lines can be suggested rather than stated in a more definite style.

Stretch some watercolour paper as described on page 18. Draw the outline of the head and indicate the positions of the features very lightly with a pencil. Gradually build up the darker tones with watercolour, working in broad areas and keeping the paper damp so that the edges of the colours remain soft.

PASTELS

Try drawing with oil pastel on pre-pared canvas. Stretch some paper, and when it is dry place some cotton canvas or unbleached calico over the paper and brush on some hot size to bind the two together and provide an impervious surface. You could mix some diluted acrylic paint with the size to give a basic tone and colour to the canvas.

When the size is dry, start drawing with the oil pastels. When brushed with turpentine the pastel will dissolve (as with pencil) and can then be used as if it were diluted oil paint. Drawing with the pastels on the rough surface will produce an interesting texture.

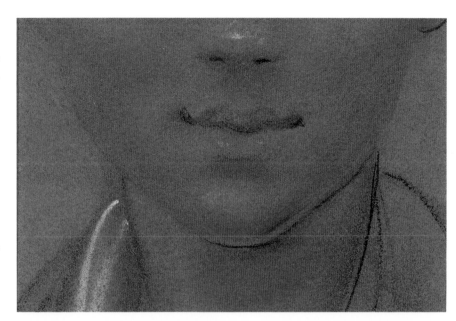

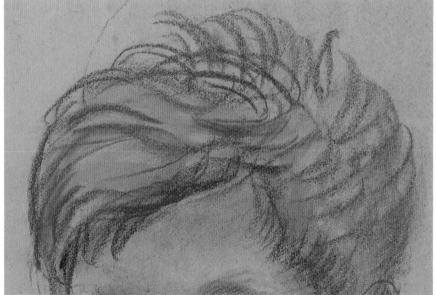

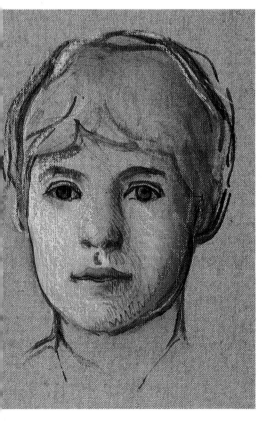

Now experiment with ordinary, soft pastels on toned paper. This medium is particularly suitable if you want to express a quality of softness. (Like charcoal, soft pastel must be fixed to prevent smudging.)

OIL ON PAPER

For both quick sketches and more finished paintings of children the technique of using oil paints on prepared paper is perhaps the most versatile. It cannot be overstated that the key to the art of painting children is to assess spontaneously the forms, contours and colours and then, again with spontaneity, to apply these to your canvas or paper.

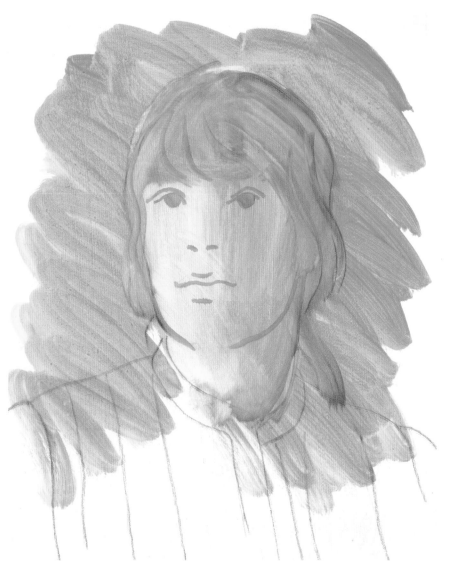

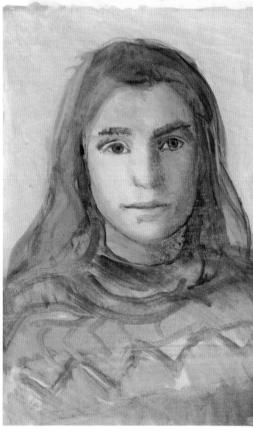

Try a similar approach on sized paper (see page 18) and experiment with different types of paper. Interesting effects of texture can be achieved, again by applying the paint and then rubbing down. When using oil paint on prepared paper, remember that colours are lightened by rubbing through to the white paper (*above*).

Now try painting on paper primed with shellac (it need not be stretched). This will give a gritty surface. Mix some dry powder colours, selecting them to relate to the character of the sitter. Aim for translucent colour effects. Mix white with your colours during the final stages to accentuate the highlights (*opposite*).

Stretched paper can be primed in one of two ways to prevent the oil from penetrating the surface. The first is to apply a layer of emulsion paint or acrylic white primer. This produces a slightly rough surface for the paint to bite into so that a colour stain will remain when you rub on an initial wash with a rag. Trace the outline of your portrait onto the paper. Freely paint on a background colour using oil paint well diluted with turps (on a vertical surface the paint will run if it is too diluted). Then rub away the form of the head with a rag. Paint in and then lightly wipe a colour for the head, and then give an extra wipe to lighten one side of the face. Paint in freely the hair, and draw in the features with a fine brush. Use the tracing again to redraw the shape of the head and shoulders.

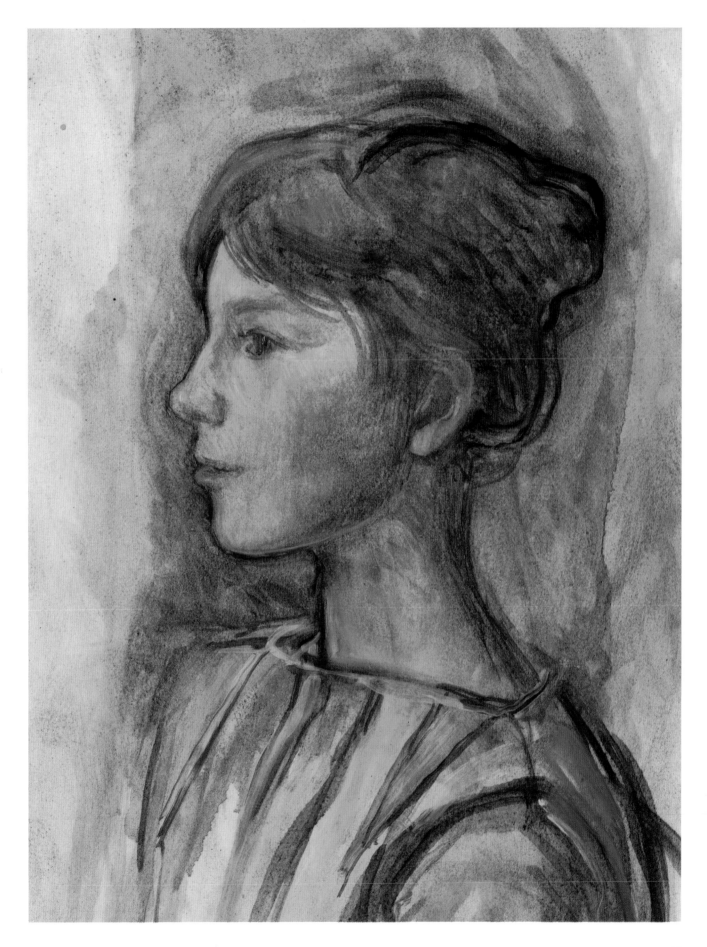

OIL ON CANVAS

Most of the finished portraits shown in this book were painted on stretched canvas, but for sketches and experimental work in oils I recommend canvas, cotton duck or unbleached calico sized onto paper as described on page 21 or applied to board in the same way. This is cheaper, more manageable and quicker to prepare than stretched canvas and will therefore encourage you to work more freely. It also provides a very firm surface for rubbing paint into, as suggested below.

The liveliness of your painting relies on lively and adventurous methods of working. The colours should reflect the vitality and translucency of a young face. The skills learnt through the technique of oil on paper can now be taken a stage further with oil on canvas, but it is the texture of the canvas that makes the basic difference. The colours are 'fixed' more securely in the tooth of the canvas and the painting will have more depth.

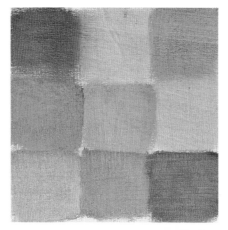

Apply canvas to paper and size it as described. Begin by trying out some colour combinations mixed from a simple palette (raw umber, burnt sienna and yellow ochre, with white). Paint in the main areas of the head and shoulders, and experiment with the textures and colours of the cheeks. Pick up some colour with a piece of rag on the end of your finger and rub it into the ground colour.

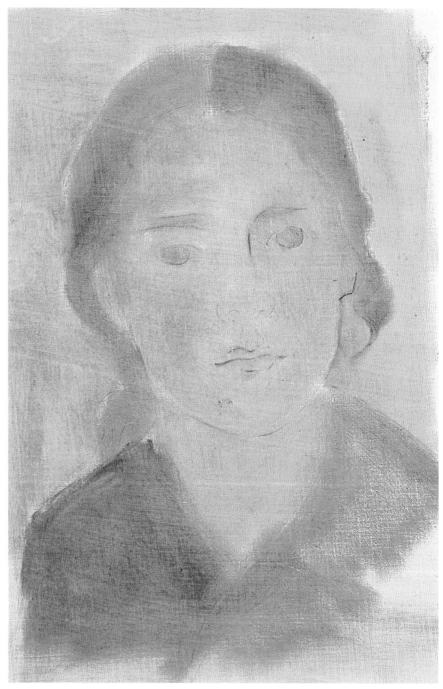

24

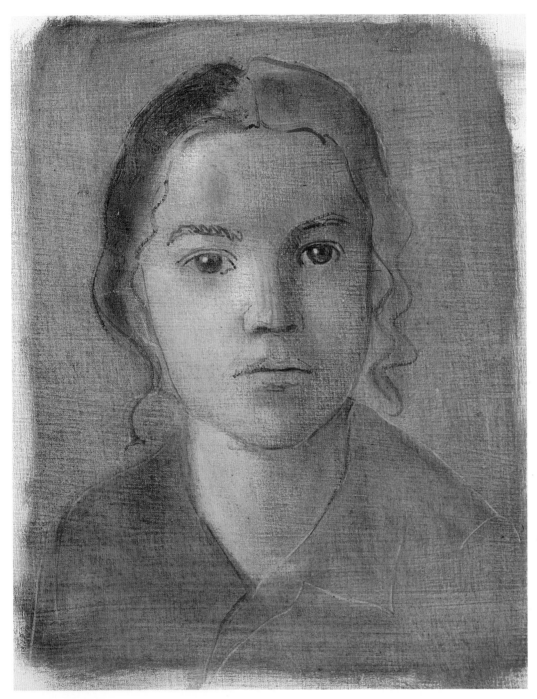

Now try a different colour combination without white, using black, raw umber, burnt sienna and yellow ochre, and proceed as above. For the light tones, soak a rag with turpentine and rub down to the canvas. The highlights in the eyes are made by lifting the paint off with turps and a fine brush.

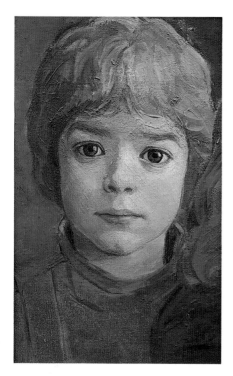

The flexibility of oil paint provides a wide choice of possibilities in the treatment of texture, colour, tone and drawing. You can wipe, scrape, paint over, paint thickly or thinly. Vary the textures within the painting to add interest; but if the paint is impasto (thickly applied so that brush marks are evident), make sure that the colours do not become muddy through over-mixing. Let each layer dry before adding the next (you can use a drying agent, which also makes the paint more fluid), or before glazing over with another colour (see page 76).

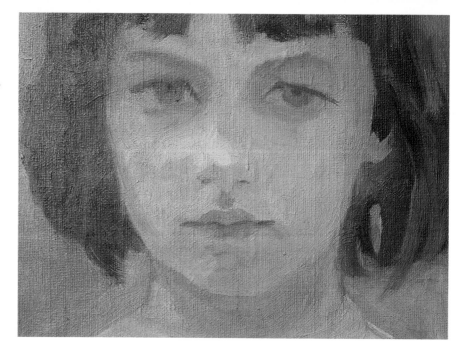

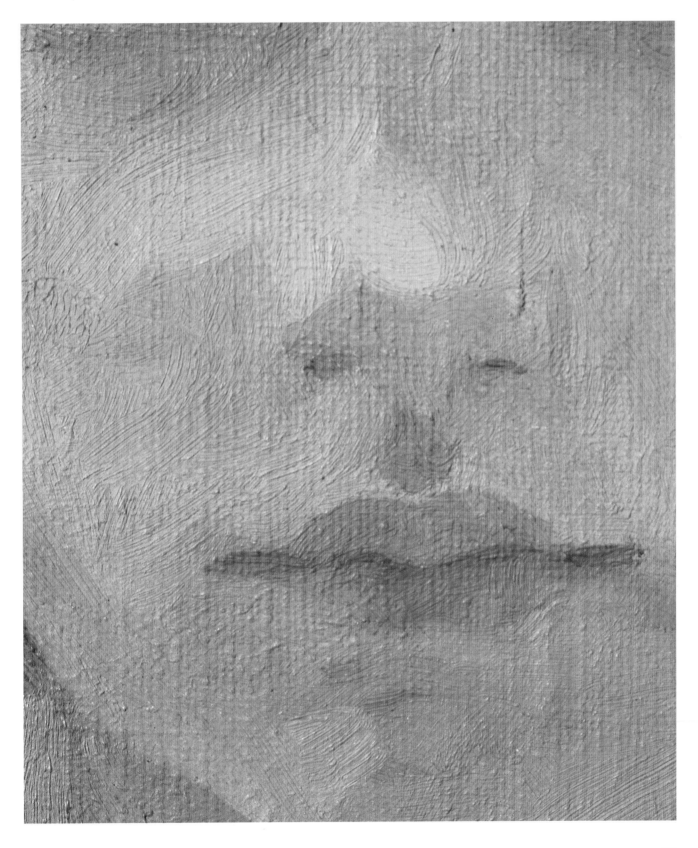

RESUMÉ

The choice is yours. The possibilities and permutations of different media and techniques are endless. Be adventurous, and try to relate your method of painting to the character of your sitter. A selection of quick sketches is shown here, and applying the various techniques to different types of portrait will be illustrated later in the book.

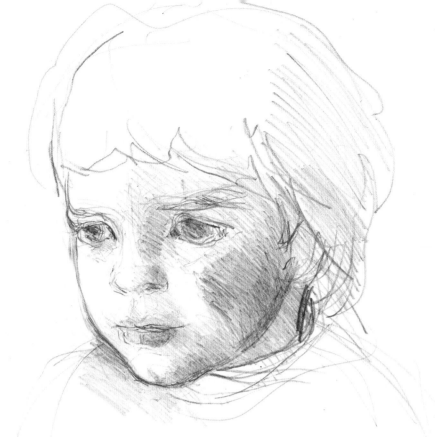

Soft pencil on cartridge (drawing) paper

Hard pencil on cartridge (drawing) paper

Pencil and oil on sized paper

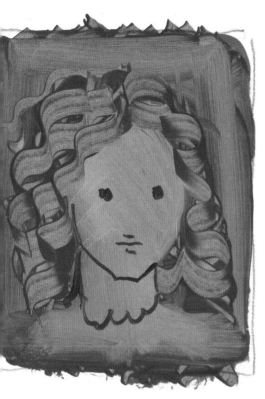

Thinned oil paint on sized paper using a brush for lines and a cardboard palette knife for the hair

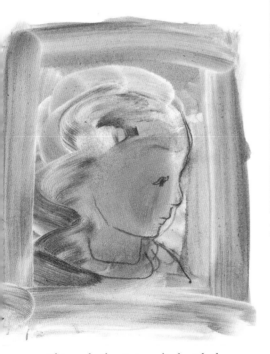

Thinned oil paint applied with the thumb and by rubbing, with pencil

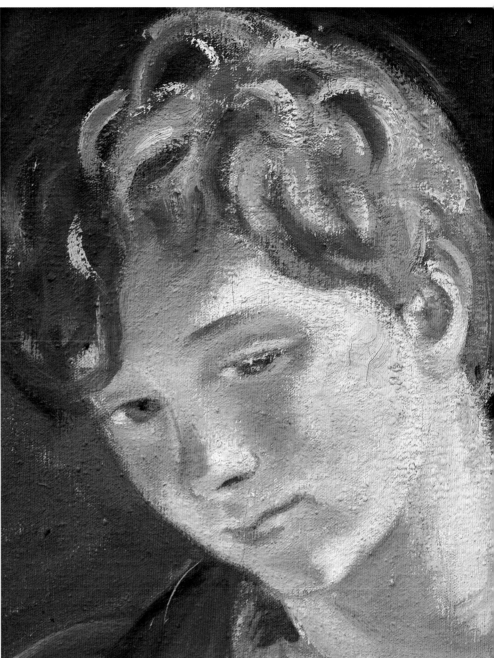

Fra *by Elizabeth Chaplin. Oil on canvas*

2 · SOME USEFUL SUGGESTIONS TO GET YOU STARTED

HELPFUL IDEAS AND EXERCISES

One of the most essential things to capture when painting children is the distinctive quality of spontaneity.

The shapes and rhythms of a child's body are never static. Facial expression varies rapidly with the constant shifting of mood or interest. All forms of portraiture rely on a sound technique of drawing, but when painting children you must also develop the ability to note very quickly the complexities of the moving shapes in front of you. This requires practice, but it is the only way you will succeed in conveying the child's animation.

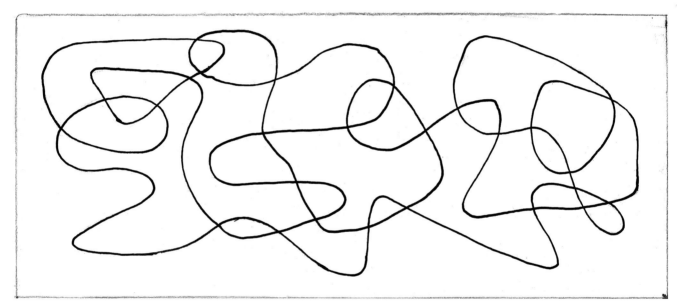

Train your eye to select rapidly the shapes and colours that form the essence of the child's character, and in particular look for the relationship between these lines, colours and forms. For example, a characteristic tilt of the head is brought to life by the relative slope of the shoulders, or the dark tone of the hair by the light tone of the cheek or background; and there is a difference in the shape of sad eyes and laughing eyes.

If you understand a form, you will be able to draw it. These three shapes –

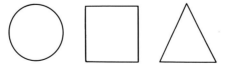

circle, square and triangle – can be drawn without difficulty because they are easily understood. A more complex shape such as the 'scribble' is more difficult because it is harder to see clearly and therefore to understand. To help you translate a complex line into understandable shapes or forms, try the following exercise. Draw a continuous, twisting and overlapping line on a piece of paper and pin it up on the wall. Look at it in terms of two-dimensional shapes and draw as many of the discovered areas as you can. Look for the overall shape. Fill in the spaces with colours. Use pencil for the line or for shading the spaces, or try using any of the media suggested in chapter 1.

LOOKING FOR SHAPES AND SPACES

Test your skill in finding shapes among the objects around you. For example, draw the spaces made by the legs of a chair or stool. Here I laid a wash of thin oil paint on sized paper and drew the spaces by wiping away the paint (see page 18).

When you come to painting a group portrait you will see how important spaces are. There are exciting things you can do with them to make a portrait lively and interesting.

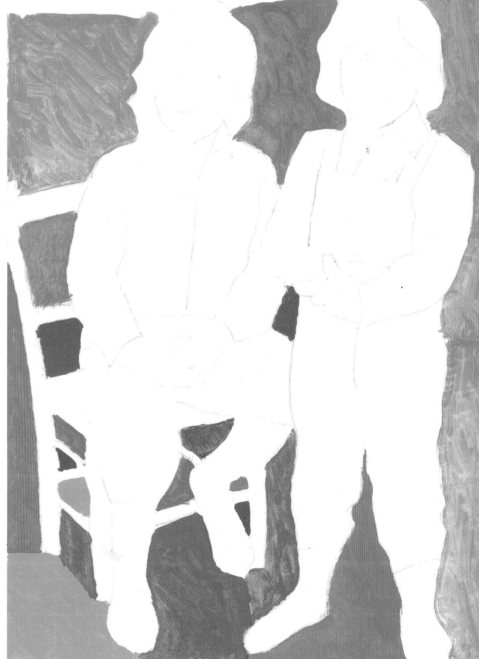

SEEING THE SHAPE OF THE HEAD

You are now becoming familiar with the idea of looking for complete shapes, so you can begin to use your skills to draw the contour (or overall shape) of the child's head. Practice by placing your sitter against a strong light or window so that you see the head as a dark shape or silhouette. Look for the points at which the contour changes direction as this will help you describe the shape (see also page 38). Draw the head from different positions, then block in the shapes with tone or colour; in this way the form of the head becomes easier to see and understand. You have now fixed the general shape in your mind. This is a useful device if your sitter tends to move around.

THE GRADATION OF TONE

The play between light and dark on a child's face is exciting to paint. Highlights can accentuate the glow of a cheek, and the roundness of the form is indicated by the change from light to dark.

These two circles illustrate how important it is to understand tonal change. The white discs in the centre are the same size. On the black and white circle, the contrast in tone is so piercing that the inner disc is like a hole and does not lie on the surface of the black. On the other circle, the tone has been graded from the centre; notice how here the inner white disc glows, and the overall surface has assumed a form.

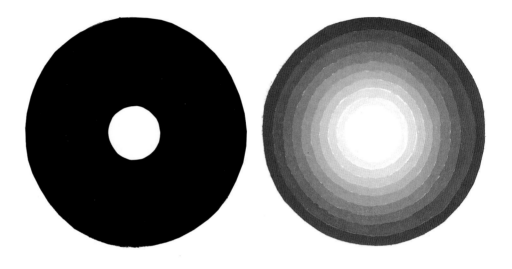

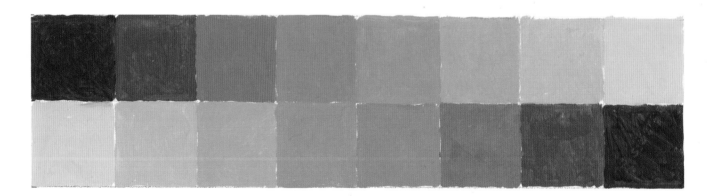

The following exercise in tonal gradation may help you to understand tone. Draw two strips of squares. Using burnt sienna (a very useful colour for skin), paint the first section of the top strip and the last section of the bottom strip in undiluted colour. Continue along each strip, at each stage adding white to the previous colour. When you have finished, notice the wide range of interesting colour and tonal relationships. Then begin to apply these tones and colours, from the darkest to the lightest, to a face. Discover how you can make highlights and light areas glow.

CONCENTRATION

Before you start a painting, make a careful note of the position of the lightest and darkest areas. To help you become familiar with this procedure, first try mapping out on a grid the light, dark and intermediate tones. This will improve your ability to observe with concentration.

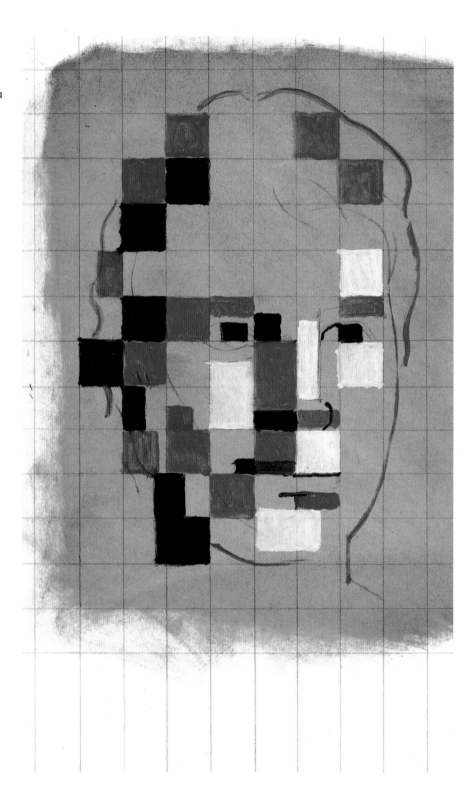

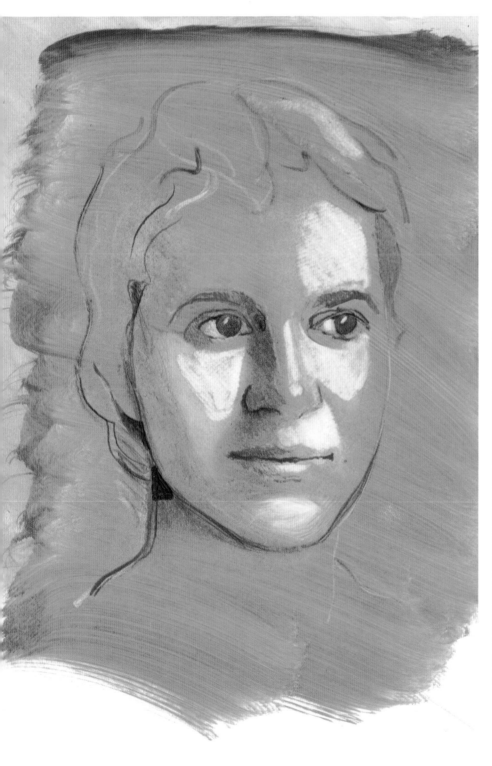

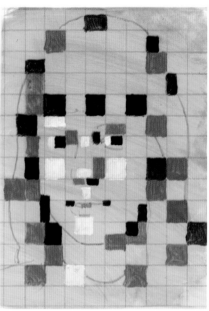

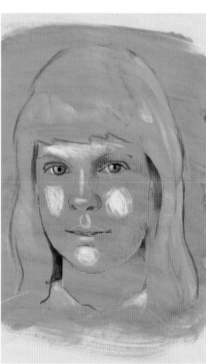

DRAWING QUICKLY

The ability to draw quickly and confidently is indispensable and must be kept in good order by constant practice. When you are drawing with a pencil, your eye will tend to interpret the subject in terms of line rather than form, and to enable you to describe the form quickly and naturally it is essential to know what to look for. Always look for the point on the contour where the line changes direction. Move your eye across the form and link up one change of direction with another. Within the form, try to move your pencil along the lines where tones change, indicating a change of plane on the form. Draw fluidly without taking your pencil off the paper, and move your eye from side to side and from point to point as you draw.

Analyse shapes that you see around you and discover for yourself the structure of their form. For example, before you eat your next apple, cut it in half horizontally and trace the contour. Notice the definite points where the line changes direction. Join the two halves of the apple together and look at the changes in tone. This will help you to draw the apple with better understanding.

Feel the form with your pencil, remembering all the time that it is three-dimensional and that your interpretation must convey this solidity.

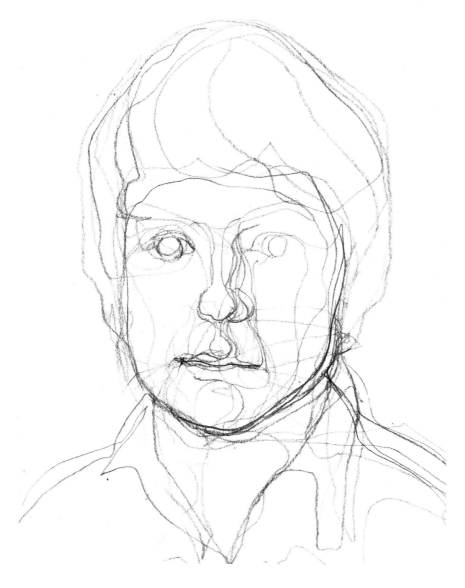

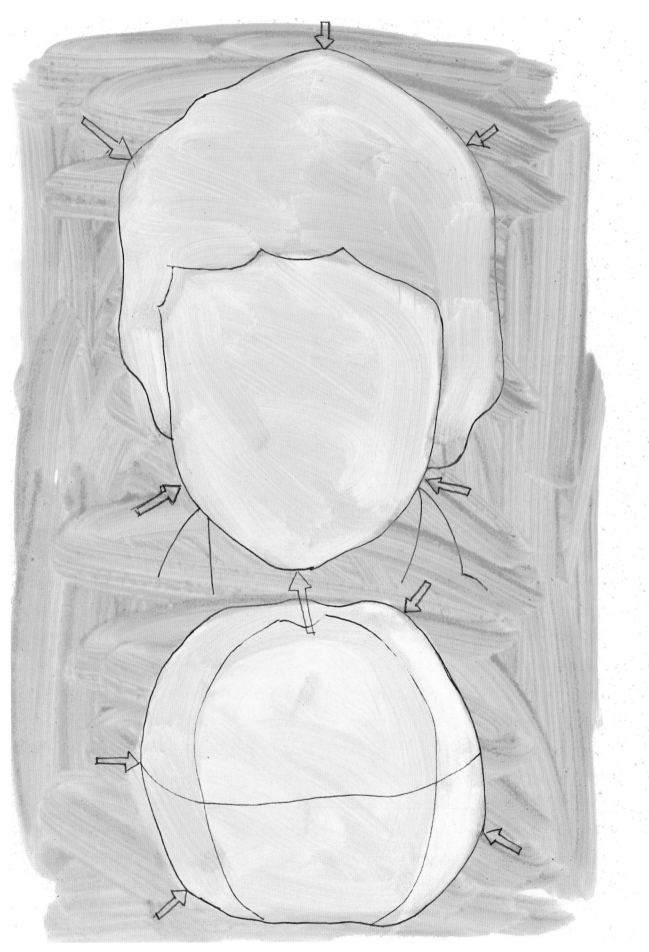

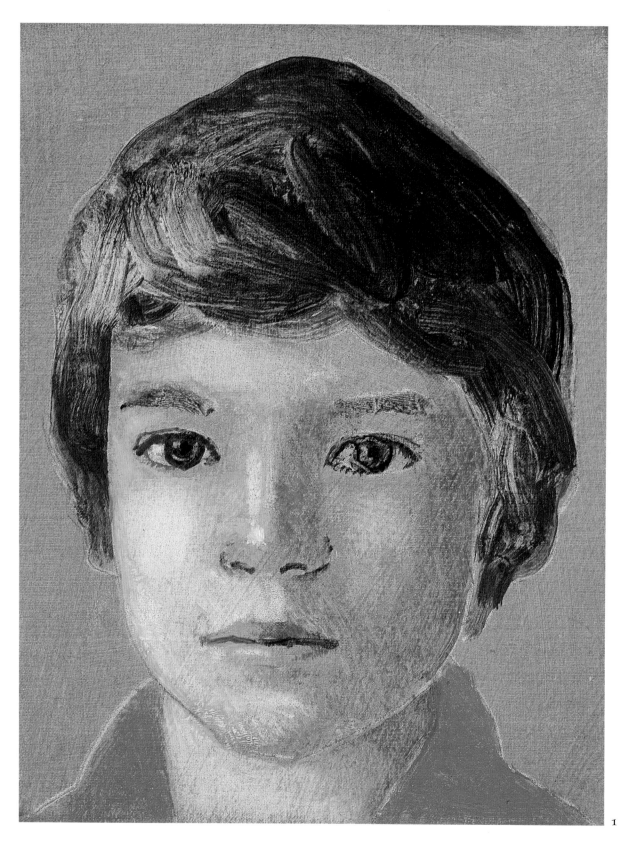

1

FRESHNESS

This colour exercise will help you achieve the quality of freshness, an important factor in painting children. Using calico sized onto paper as a painting surface (see page 21), I have done three studies of the same young boy. For each sketch I have chosen a simple palette of three colours: (1) titanium white, black and raw umber; (2) titanium white, yellow ochre and burnt umber; (3) titanium white, burnt sienna and viridian green. It is possible, as the illustration shows, to achieve a surprisingly wide range of colour effects with white and just two other colours, and each study has its own distinctive character. An extra dimension can be given to a colour by wiping through to the white surface rather than by adding white.

Experiment with these simple colour combinations until you are familiar with them, and then invent your own limited palette. Aim to choose a group of colours that will relate to the character of your sitter – perhaps cool colours for a tranquil child or warm for an ebullient one. A simple palette will keep the colours fresh and youthful.

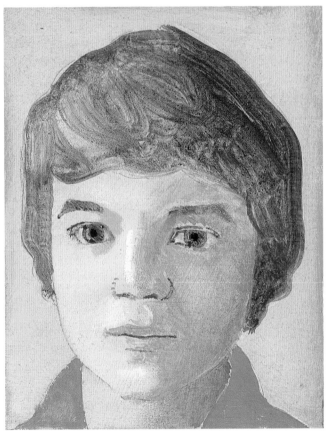

2

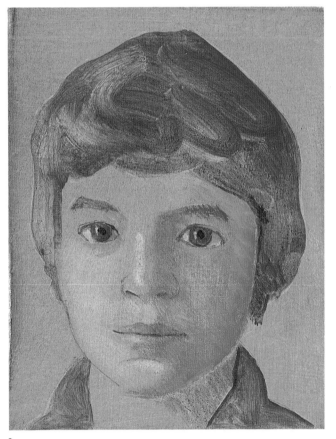

3

DRAWING AIDS

The success of a painting depends on good drawing. The eye takes in shapes and contours; the mind transposes them into understandable forms and then the hand moves the pencil in the right direction. The more you draw the better you will learn to see, and the better you see the quicker your drawing will improve.

Here are some ways in which you can help your eye to take in information:

1. Divide and mark a length of weighted string into equal parts and hold this at arm's length to line up with your subject. With one eye shut, compare the relative distances against the marks

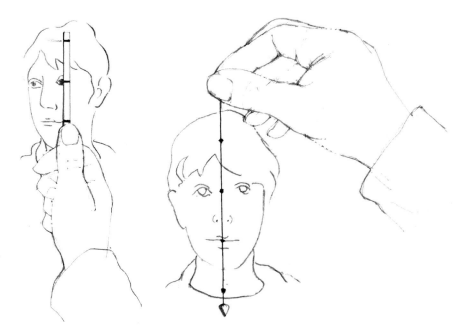

on the string. (You could use a marked ruler, but the advantage of the string is that it provides an accurate vertical and does not obscure any of the subject.) This method is particularly useful when fixing the pose.

2. Fix a sheet of clear perspex (Plexiglas) in a frame and place this on your easel so that you have an uninterrupted view of the sitter through the plastic. With one eye shut, and keeping your head as still as possible, trace the outline of the figure onto the perspex with a fine felt tip pen. Draw as quickly as possible and concentrate on the main proportions (head, shoulders and hands) and the flowing lines of the outline of the figure. Mark in the relative position of the eyes, but leave out any other details unless your sitter can remain very still for a few minutes.

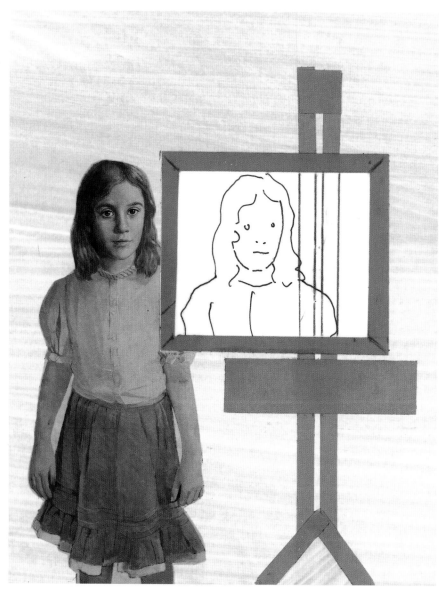

Place the perspex on a piece of white paper, cover it with tracing paper and trace off your line drawing. Then clean the perspex and repeat the process. The size of each drawing will vary according to the relative position of the sitter to your own.

Choose the best of the series, square it up and use it to plan the composition (as with the line drawings traced from sketches, page 88).

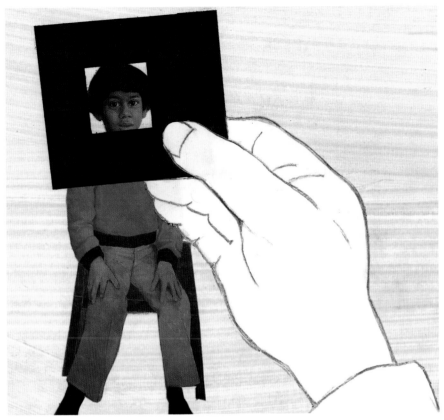

For very young children, it is useful to sit or stand them on a dais; this could be made from a wooden box wide enough to support a small chair. (Often children have their own favourite chair.) Aim to bring the height of the child's head up to your own eye level. The dais has another useful purpose – it helps to prevent the child from running away!

3. Take a piece of black cardboard and cut out a small square from the middle. With one eye shut, adjust the position of the cardboard to enable you to see a particular part of the face or body through the opening. (The closer it is to your eye the more of the figure you will see.) Concentrate your eye on the colour and tone. The area of colour you see has been isolated by the neutral black and is therefore much easier to assess. Observe specific colour relationships: for example, between neck and shirt or between the light and dark sides of the face.

4. Whatever method you use for drawing or painting, always make sure that the figure and your picture can be seen together without too much movement of your head. Sit on a comfortable chair, have plenty of space around you, and position your easel at arm's length.

43

COLOUR RELATIONSHIPS

Here are some more ideas about colours and how colour relationships can play an important part in your painting. These two pairs of colour patterns show how a colour can change its character according to the colour it lies next to.

The first pair is made up of squares of the same colours – titanium white, white with burnt sienna, white with burnt umber, and yellow ochre. The backgrounds are different: one is Prussian blue mixed with burnt sienna and white, the other cadmium red with white.

The second set has inner squares of titanium white, raw umber, Mars yellow and cadmium orange, with backgrounds of green (sap green mixed with Mars yellow) and of burnt sienna lightened with cadmium orange. Notice how much the colours of the inner squares appear to change against the different backgrounds.

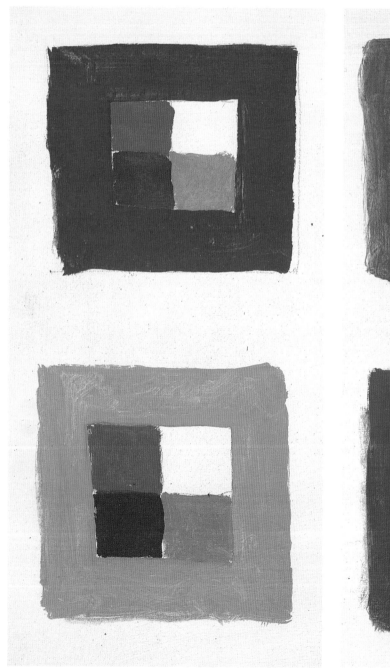

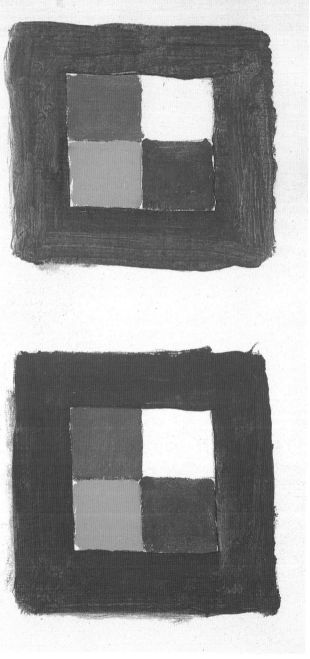

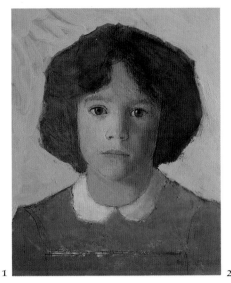

1

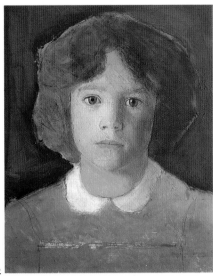

2

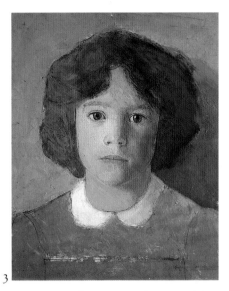

3

Now see how different backgrounds can influence the character of a painting. (1) Viridian green with white: this pushes the head forward and the cold colour emphasizes the pinks and warm colours on the face. (2) Cadmium red with some burnt sienna: here the head lies behind the background and the red accentuates the green in the eyes. (3) Raw umber, yellow ochre and viridian with white: this conveys a calm and harmonious atmosphere.

FLUIDITY

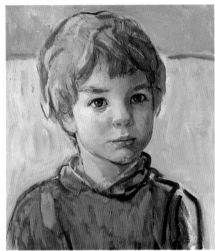

There is nothing static about a child. Your ability to paint with fluidity depends on your confidence, your confidence depends on a sure technique, and a sure technique depends on knowing what to look for and what to select. And all of these depend on constant practice.

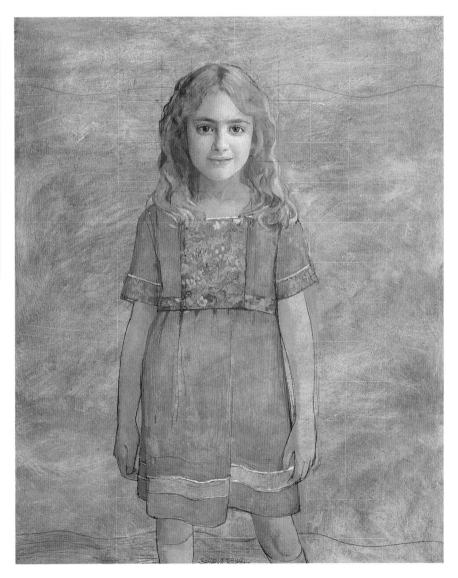

STUDYING THE MASTERS

You may find it constructive to study portraits of children by well-known painters. If the original is not accessible there are plenty of books with excellent reproductions. The value of this is to compare different styles and to understand that the distinctions arise from each painter choosing to look at the child in his or her own particular way.

Picasso has miraculously conveyed the particular qualities of a very young girl by choosing to see her in terms of

after Picasso, *Paloma; the Artist's Daughter*

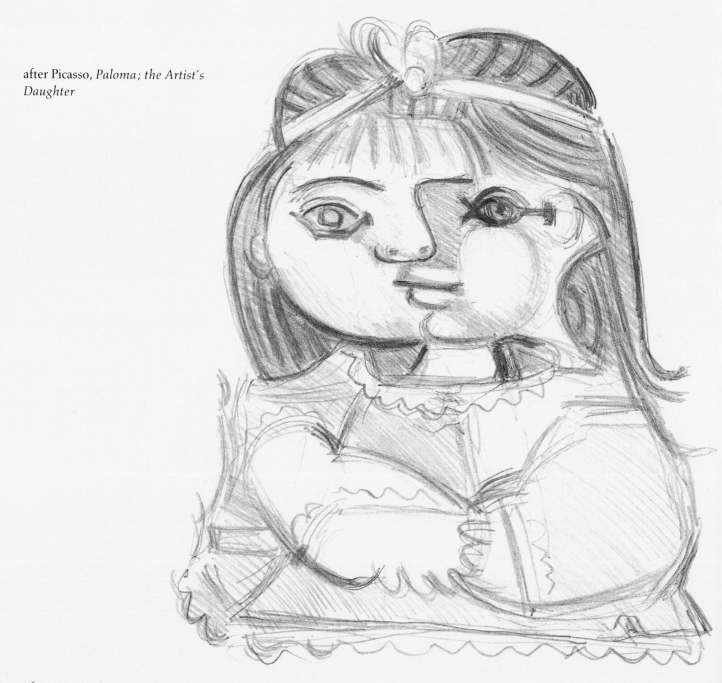

simple related shapes. In the portrait by Van Gogh the young boy's vulnerability is revealed through the expression and the pose. Notice the relative position of the shoulder line to the cheek, emphasizing the frailty of the stooped head.

You too must respond imaginatively to your sitter. Try to select the qualities that seem to you to express the spirit of children as well as the qualities that reveal the character of the child you are painting.

after Van Gogh, *Head of a Boy*

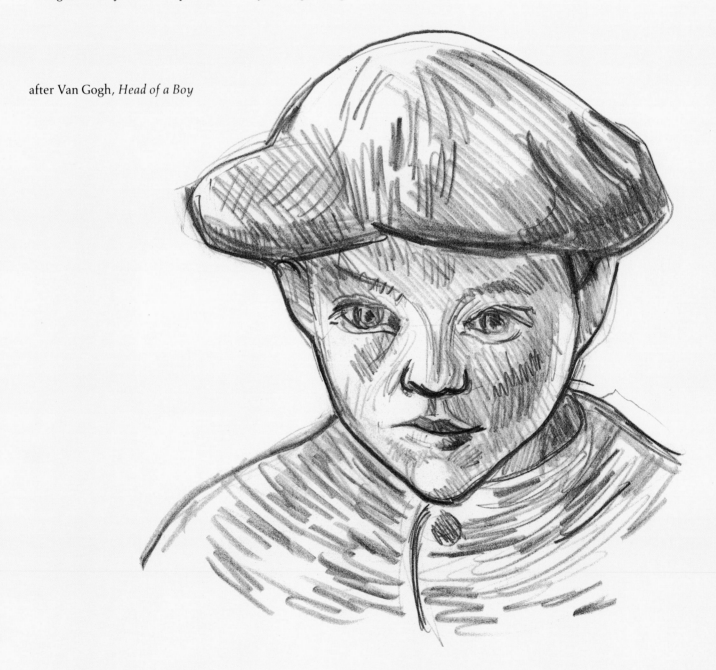

ANALYSING A PAINTING

I have chosen to do a copy of a painting by Renoir of the two daughters of Monsieur Cahen d'Anvers. Notice how sensitively the two characters have been suggested by the contrast in poses: the younger, on the left, sturdy on her feet but a little shy; her elder sister, the hands and delicate feet more posed, giving a hint of approaching maturity.

I used pencil and turpentine on sized paper (see page 18). The turpentine dissolves any area of pencil line or shading that becomes too complicated. I can then use a brush to emphasize the flow of a line, or a rag to wipe away unwanted areas of grey. Practise using this technique when making studies of children. It allows you to explore rhythms and flowing lines with great freedom. These lines, which convey the feeling of animation, must always form the basis of your portrait.

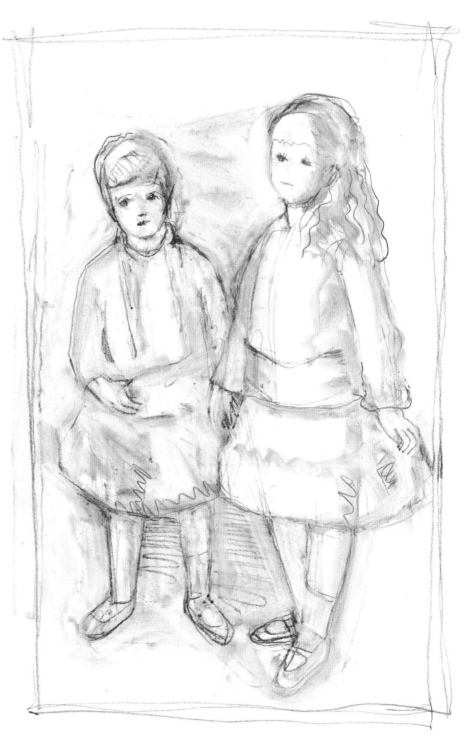

after Renoir, *The daughters of Monsieur Cahan d'Anvers*

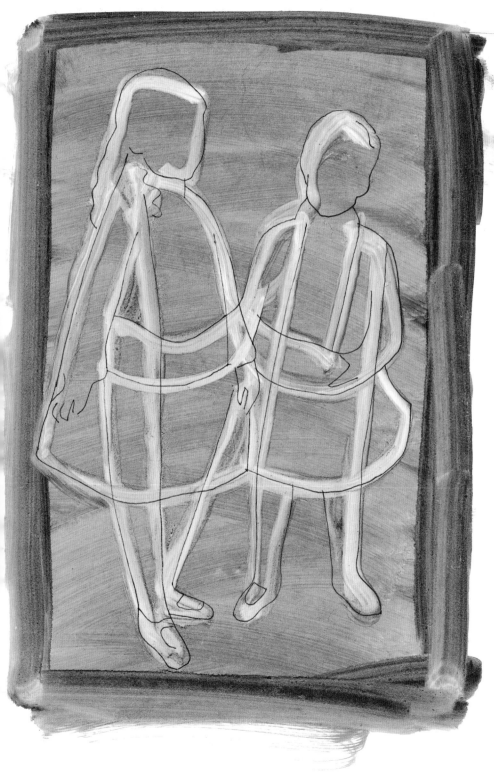

It would now be interesting to discover a rhythmic line that flows through the basic structure of the portrait you are studying. Place a sheet of tracing paper over your drawing and trace a line with a fine felt pen. Start at a point on the contour and then move over the figures from side to side and from top to bottom, keeping the line simple and continuous. Transfer this line onto a sheet of paper and play around with it. I reversed the image and drew my line on sized paper with a felt pen. I then covered the line with a wash of thin oil paint and freely drew over it with brush and turpentine that dissolved the paint. Notice how a reversed image seems to emphasize the rhythms of the pose.

As a general rule, it is very useful to simplify a drawing using tracing paper and then study the reversed image.

3 · HEAD, FEATURES AND HANDS

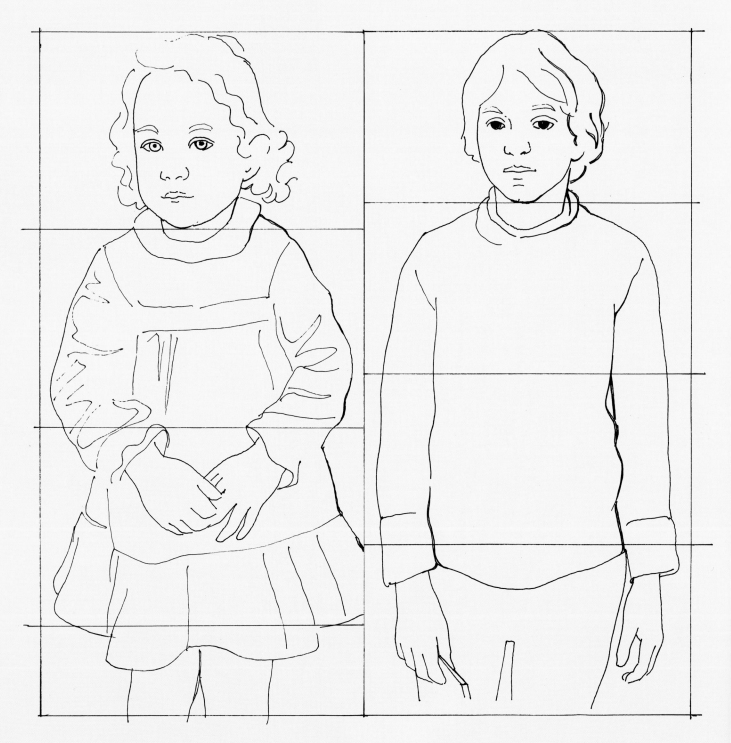

Before embarking on a complete portrait, it would be useful to consider the various components and discover what are the important things to look for and how to paint them. We have already considered ways of noting the shape of the head. Before you start thinking about the features, it is important to understand some basic proportions.

The ratio of head to body changes as the child grows older. The younger the child, the bigger the head is in relation to the body. Look carefully also at the width of the shoulders and how this compares with the height of the head (*opposite*).

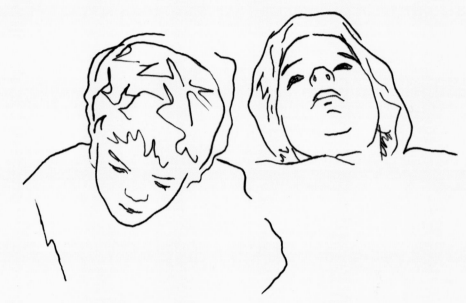

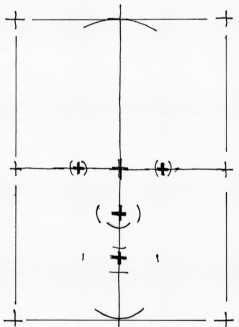

Note the basic proportions of the features within the main form of the head. The distance between the centres of the eyes is the same as that from the bridge of the nose to the centre of the mouth; and from the bridge to the tip of the nose is half this distance. The line of the eyes is halfway between the top of the head and the chin. Remember how useful it is to look for spaces and shapes, so again look carefully at the shape made by the slope of the shoulder and the side of the head.

For a three-quarter or full-length portrait, measure carefully the height of the head and see how many times this measurement 'fits' into the body. Hold vertically at arm's length a strip of stiff paper about 30 cm (12 ins) long that has been marked off in seven equal parts, lining it up against the standing figure. Note where the marks on the paper coincide with the top of the head, the chin, shoulders, waist, and so on. To help the standing child keep still, he or she could hold on to a chair or lean (as upright as possible) against a wall or screen. You could mark on the screen the actual height of the child and divide this distance into seven equal parts and then see where these marks line up against the body.

Try to position yourself so that your eyes are on the same level as the eyes of the child. Observe how much of each ear is visible as the head turns slightly to left or right. (This is useful when checking the pose at the start of each session.) Remember how forms change and become foreshortened according to your viewpoint, and check the position of the ear lobe and how its alignment with the eyes or mouth varies as the head is tilted (*above*).

Faces are never completely symmetrical. Careful observation will help you to find the subtle variations between one side of the face and the other, one eye and the other.

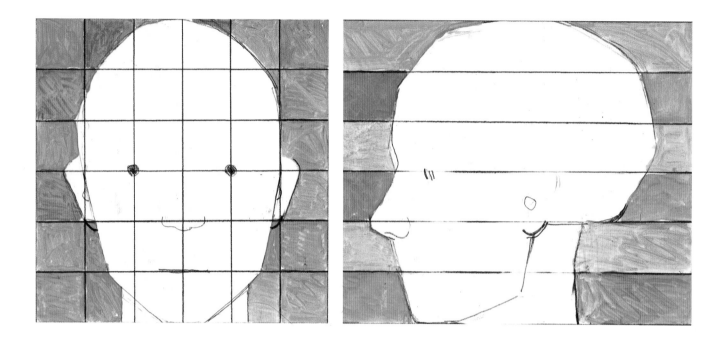

Another useful way to help you to understand the divisions and proportions of the features in the head is to imagine the frontal view divided by a grid. Again, consider the relationship between the bridge of the nose and the tip (where you see the highlight). This distance will fit six times vertically and four times horizontally into the area of the head.

Now look at the profile and see how the head is divided into six parts. Notice particularly the line from the tip of the nose through to the ear and to the back of the head.

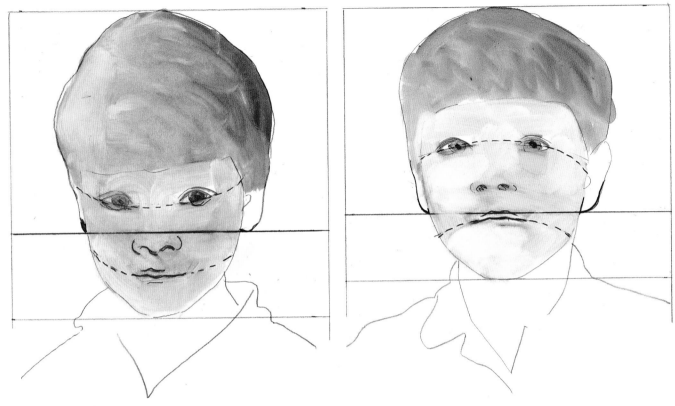

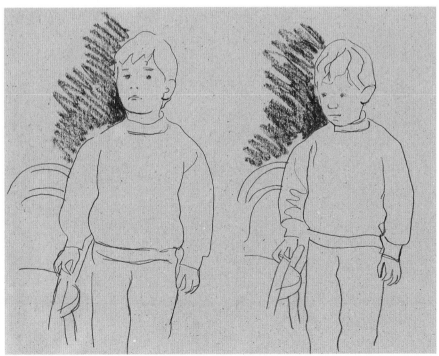

Hold a pencil horizontally and at arm's length in front of your subject. With one eye shut, line up the pencil against the ears and notice where this line passes through the face. At the same time, note the ratio between the area of the hair and that of the face, depending on the tilt of the head.

Always remember that the features lie on a curved surface and that the line of the mouth and eyes also varies as the head is tilted up or down, as does the jaw line and its relationship with the shoulder line. Note the child holding onto a small chair to help him keep a steady pose.

THE HEAD

Look for the things that you think are unique to a child (that distinguish a child from an adult) – perhaps the slenderness of the neck, or the smoothness of the brow and skin; or, as we have mentioned, the size of the head in relation to the shoulders. It is surprising how the shape of the head varies from child to child, but an abundance of hair often prevents you from seeing the overall shape. To discover the shape underneath the hair, lift the hair up from the nape of the neck to see how the back of the head is formed, or smooth the hair back from the sides and tuck it behind the ears so that you can see the full width of the face. This last is important because it determines the set of the eyes. Wide-apart eyes are usually set in a wide face.

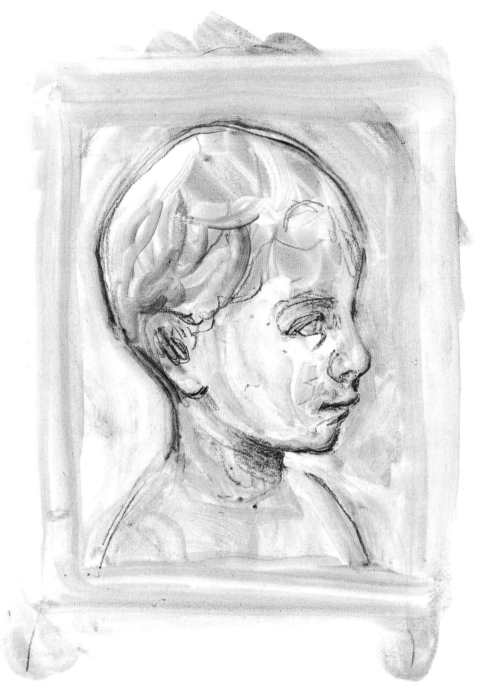

The contour of the cheek and chin will give you a clue about the fullness and shape of the face. It is useful to know that this contour shows you where the front plane of the face changes to the side plane. Try to see this change of plane on one side of the face by looking at the contour of the opposite side. Imagine, or draw, a cube: whatever your viewpoint, the edge of the cube is where one plane changes to another plane. Imagine this edge as the contour of the face.

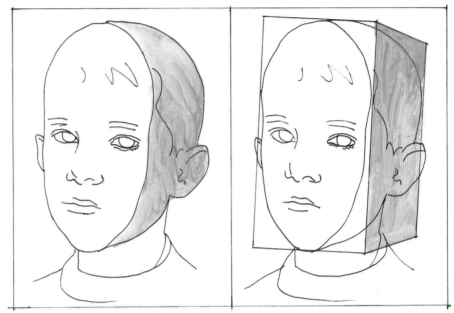

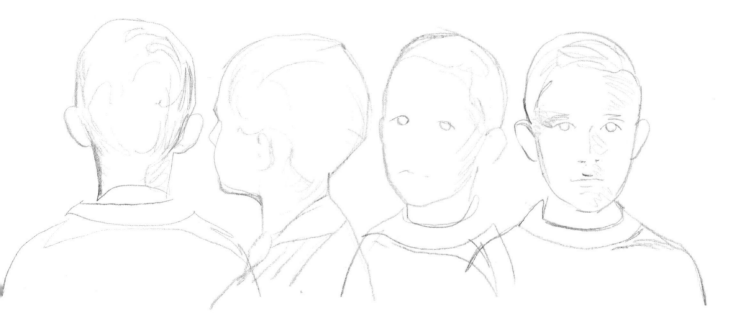

Before you actually start the portrait, spend a little time doing some quick sketches from different viewpoints. This will enable you to fix in your mind an image of the complete form. (This is very helpful when your subject finds it difficult to keep still.) Concentrate first on the overall contour, look for the changes in direction, and then bring your eye to the forms within. Try to disregard the features for the moment.

THE NOSE

Painting the features – nose, eyes and mouth – will be described in separate sections in this chapter. But with all of them you must understand and

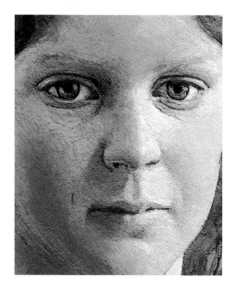

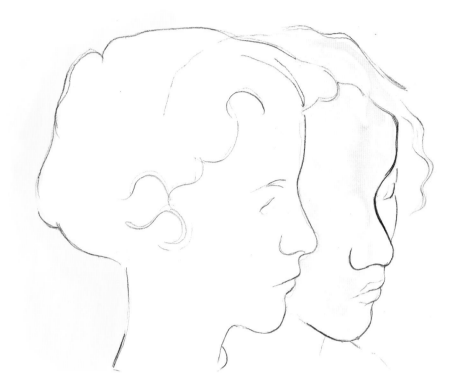

remember that the forms and spaces surrounding each feature, as well as the features themselves, ought to be

seen as one unit within the solid form of the head. For example, the contour of the nose seen in profile slides down

from the forehead and, as the head turns, the contour follows the line of the eyebrow.

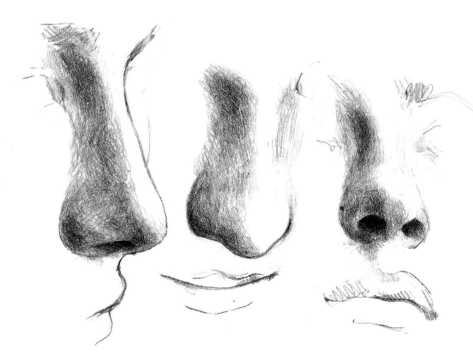

You have tried to fix the form of the head in your mind by understanding what it looked like from many different angles. Do the same with the nose. Note the bone structure of the bridge and the form of the nose tip and nostrils. (The illustrations on pages 58–9 were done from a fourteen-year-old boy.) With a young child in particular it is important to know the line of profile. The bone structure of the bridge of the nose is not yet fully developed and so a flattened form between the eyes, together with a short nose, are very characteristic; and also the tip of the nose is fleshier and the form is therefore undefined (look at the first illustration on page 54).

Look very carefully, too, at the space between the line of the eye socket and the line of the form that surrounds the nostrils. The shape of the nostrils articulates the character and expression.

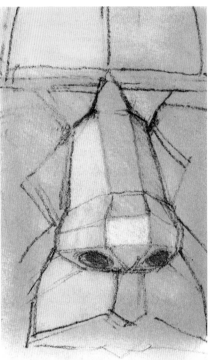

Remember that the structure of the nose is three-dimensional, with front, sides and underside.

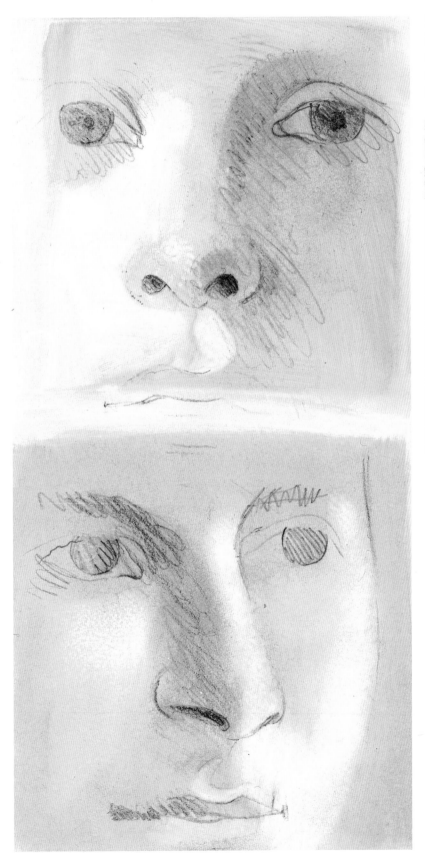

PAINTING THE NOSE

Here the head is turned slightly away from the full-face view but both sides of the nose can still be seen. The form of the bridge, the space between the eyes, the profile and the relationship between the tip of the nose and the centres of the eyes (forming a triangle) have all been considered and worked out. As you draw, try to imagine how the nose would appear from different viewpoints, particularly from the side (in profile).

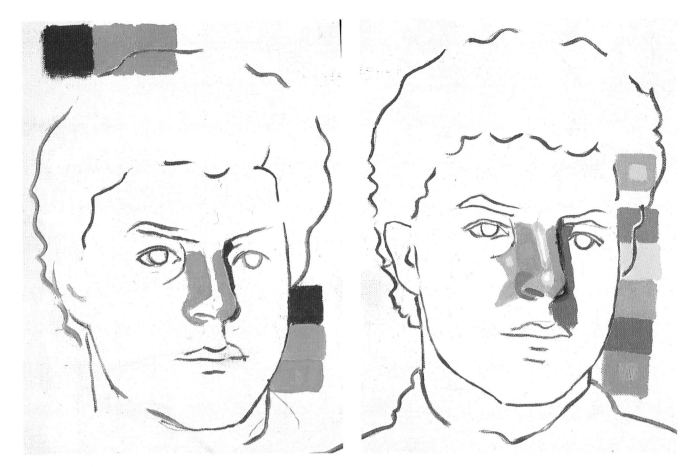

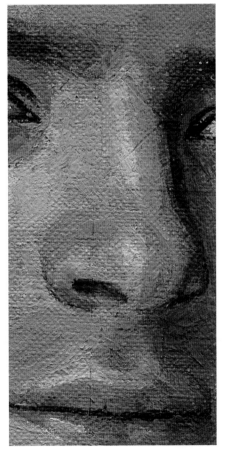

1. An outline of the head and the features has been mapped in with burnt umber on a prepared white canvas, noting carefully the grouping and position of the features within the face. With an initial palette of burnt umber, burnt sienna, yellow ochre and titanium white, a mix of burnt umber with a little white has been used for the dark side of the nose (a narrow strip) and white with yellow ochre for the other side (notice the shape). The canvas has been left bare for the lightest tones and white with a little burnt sienna has been used for the front of the nose.

2. Next, the palette is enlarged with Mars yellow, Mars orange and cadmium orange. The sides of the nose begin to extend into the forms of the cheeks and upper lip, and the white canvas of the highlight is reduced by two lines of white mixed with cadmium orange. A patch of white with Mars yellow is added to the area of yellow ochre (*above right*).

Notice all the colour combinations that can be mixed from the chosen palette. The darkest tone loses its starkness when a slightly lighter tone is placed next to it, and as the white of the canvas is covered so all the tones and colours assume their true value. (Remember the exercise in tones, page 34.) The simple form of the nostril is painted in and the colours and tones within the sides, the front and the lightest area are modified and refined (*left*).

You may of course choose to use a different technique – for example, oil on paper, or rubbing the paint onto a firm fine canvas. But whatever technique you use, always study the form so that it is fixed in your mind (remember that children do find it difficult to keep still!), and always look for the main shapes surrounding the form.

EYES

The forms surrounding the eyes, and also the forms of the eyelids and eyebrows, change as the iris (the coloured part of the eye) moves from side to side or up and down. Even when the head is still, the eyes will be moving, and a child will be unable to hold a fixed gaze for more than a few seconds while sitting for a portrait. This characteristic feeling of movement of the eyes is one of the most important aspects to capture in child portraiture.

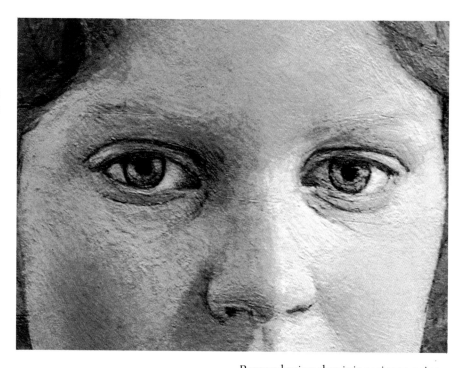

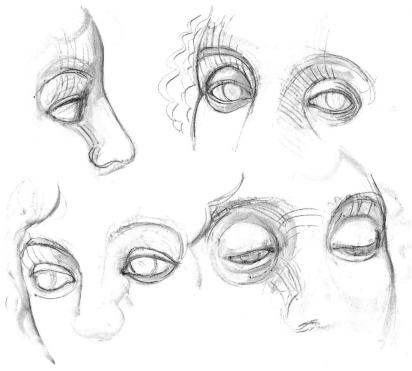

Remembering that it is easier to paint a moving form if you understand how it 'works', you should take particular care to understand the basic forms and shapes of the eye. The bones of the forehead, the top edge of the eye socket (which forms the eyebrow), the cheekbone and the form of the nose are covered closely by the skin. The eyeball sits in the eye socket, and only a segment of it is visible in the opening between the eyelids, which are formed by looser, thicker skin. This opening forms the outline of the eye, but the rounded form of the eyeball continues to be visible under the eyelids. Try to retain a 'picture' of the structure in your mind so that you can work out how the shape of the eye will appear from different angles or when the eye is turned up or down, looking to left or right, closed or open.

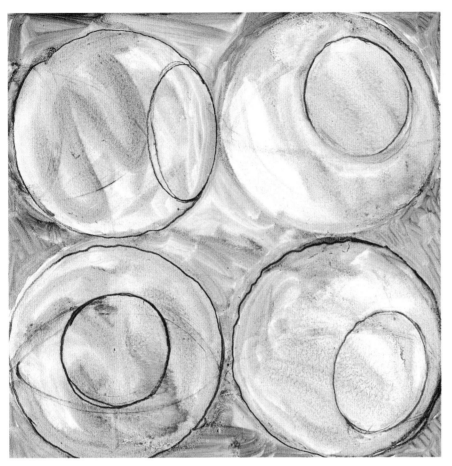

Note also that the iris is a circle on the surface of a sphere and that the shape of the circle will change as the eyeball turns. (Look at a wineglass from above, then change your position and watch the circle of the rim change to an ellipse.) Unless the eyes are very wide open, the upper and lower edges of each iris are hidden by the eyelids. Look also at the changing shapes of the white part of the eye.

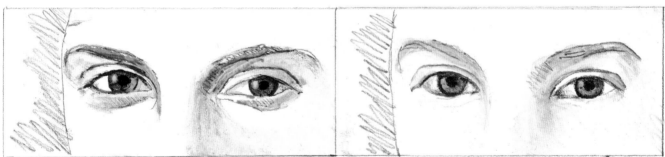

The expression in a portrait can be changed by the slightest shift in the form of the eye and its surrounding structure. Watch the movement of the eyebrows. (See also 'Expression', page 116.)

PAINTING THE EYES

1. Make a tone drawing to establish the position of the eyes in relation to the head. (As a general rule, with the face straight on, the distance between the pupils is the same as that from the bridge of the nose to the centre of the mouth; see page 51.) 'Feel' the forms surrounding the eyes. Look at the

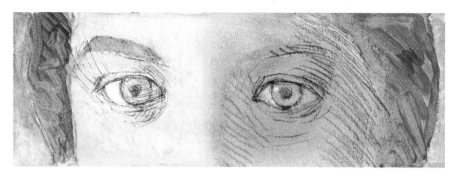

direction of the gaze and the shapes of the whites. Think all the time about how the shapes, thickness of lines and quality of the eyelashes vary from the basic eye structure. Note which side of the face is away from the light.

Make a tracing (in a clear unbroken line) from this drawing and fix the position of the pupils, the distances from the outer corners of the eyes to the sides of the face, and the characteristic distance between the eyes. Use this tracing, placing it from time to time over the painting as it progresses, to check that these important positions remain fixed.

2. As with the nose, use a limited palette. Choose three colours that you feel are characteristic, together with titanium white, for the ground colour of the dark and light tones of the surrounding skin and for the basic colour of the iris. Block in these basic colours and tones. Fix the dark centre of each iris and then draw the shape of the eye with a fine brush. Paint in the shapes of the eye on either side of the iris (one side will be lighter than the other; think of it as the side of a ball that faces the light). Paint the shape of the dark tone under the eyes and draw in the eyebrows.

3. Establish the position of the highlight on the eyeball, being careful not to exaggerate its brightness or size. Look closely at the iris and note the quality of the outer ring and the variations of colour within. Add a fourth colour to your palette if necessary. Vary the tones of the upper and lower contours, and build up the colours and tones surrounding the eye. Place your tracing over the painting to check that the drawing of the main shapes and the position of the pupils are still correct.

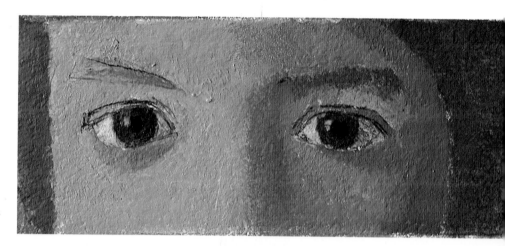

4. Fix the darkest tone – the pupil – and the lightest tone within the iris, and make final adjustments to the drawing with a fine brush. Note very carefully the depth of tone of the inner corner and the tone of the line defining the lower eyelid.

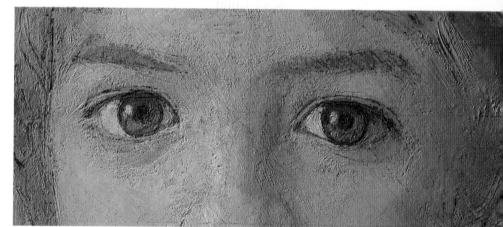

The variations of tone within the white part of the eye and the pupil will establish the expression and convey qualities of softness, brightness and moisture. Always observe carefully. You might find it a help to describe what you see in writing.

These examples were painted with oil paint on prepared board (see page 103).

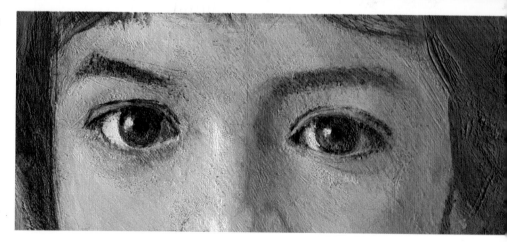

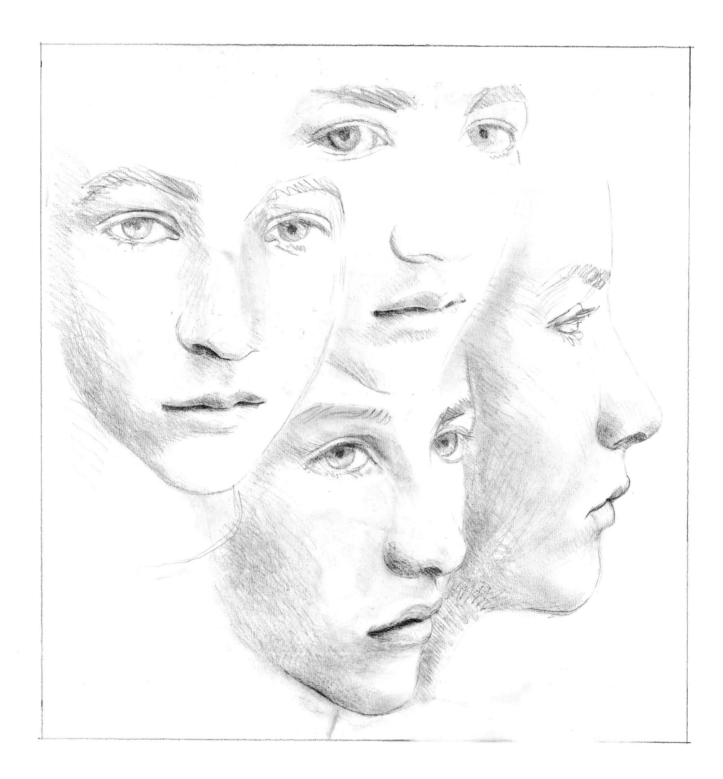

THE MOUTH

As with the eyes and nose, the appearance of the mouth will change according to the angle at which it is seen. If you understand the form, you should be able to work out what the same mouth will look like from different angles without referring to the model. This is a useful skill when painting a child who is never still. Try drawing the mouth straight on and then imagine what the profile would look like.

Think of the mouth, like the eye, as an opening in the skin covering a rounded form. The top and bottom lips are the coloured edges. The bow-like form of the top lip is shaped by the dip that forms below the nose, and the fullness of the bottom lip is accentuated by the hollow between it and the structure of the chin (*opposite*).

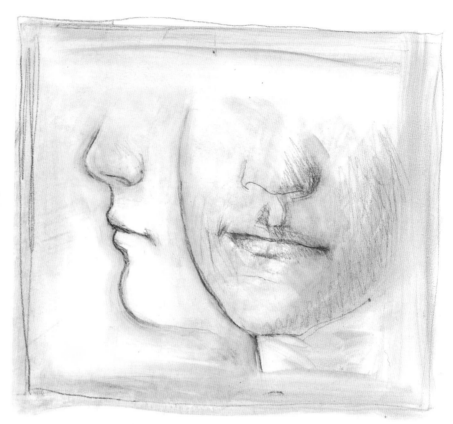

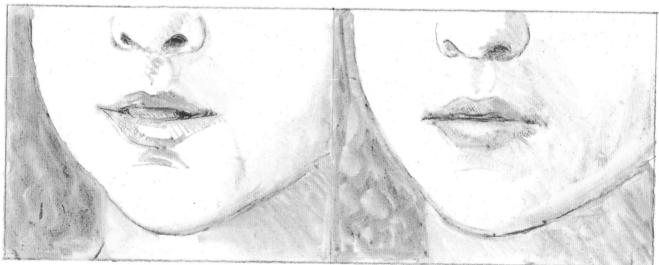

The form of the mouth must always be seen as part of the surrounding forms, particularly the chin. Be careful not to overdraw the edges of the lips; they are marked more by a change of tone than by an abrupt change of form. A sharp line or sudden change in colour and tone will destroy the quality of softness and gentle curves.

Watch very carefully the line dividing the lips, noting its tightness or softness and the resulting change of expression.

PAINTING THE MOUTH

The position of the mouth in relation to the nose should always be observed. Watch for the gap between the underside of the nose and the centre of the top lip; also note the line between the corner of the mouth and the side of the nostril. Relate the angle of the line of the mouth to the line of the eyes.

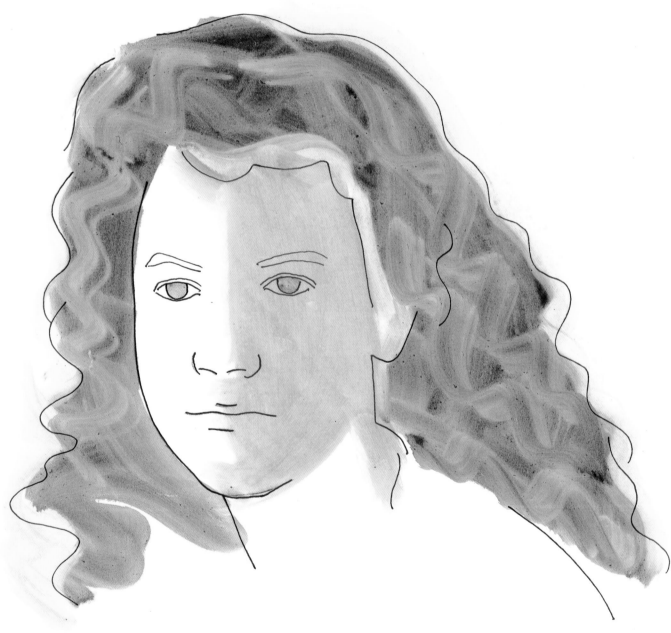

1. As with the eyes and nose, having decided on a pose (straight on, three-quarter or nearly profile?), do a drawing of the head and the position of the mouth and then make a simple line tracing which can be used to check the drawing as you proceed.

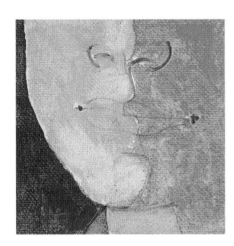

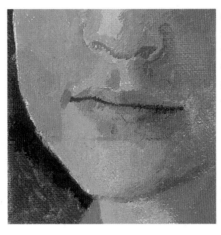

darkening the surrounding areas. Using the light red with white and burnt umber, fix the lightest and darkest tones of upper lip, lower lip and chin, and vary the tone and colour within the top and bottom lips.

2. Choose your palette: perhaps burnt sienna, burnt umber, cadmium orange and white. Position the corner of the mouth in relation to the contour of the cheek and chin and nose. Note that the division between the light side and the dark side of the face is marked by a line down the nose, upper lip and chin.

4. Continue to model the forms surrounding the lips and observe carefully the tones made by the indentations at the corners of the mouth – dark on the light side of the face and light on the dark side. The light tone is made by

5. Using a fine brush, vary the quality of the line dividing the lips (remember not to over-define their outer shape), and fix the colour and tone of the bottom lip. The correct balance of this tone is very important in conveying the expression and character of the mouth. Too much emphasis will convey a certain aggressiveness and too little emphasis will convey timidity.

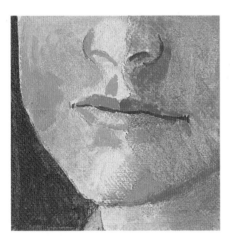

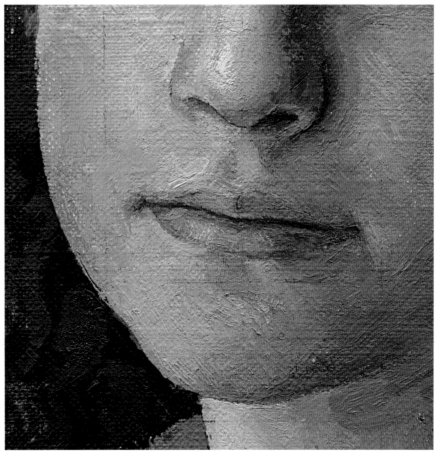

3. Increase your palette with yellow ochre and light red and work in the tones and colours surrounding the mouth. Describe the flowing line between the lips and establish the basic tone and colour of the top lip. Note the light areas of the bottom lip and the shape of the light and dark tone of the dent between the top lip and the underside of the nose.

HAIR

The hair can be a dominant part of the child's head and the area it will cover on the canvas is often larger than the area of the face, so particular care must be taken to study its character. Children's hair typically has a certain abandon and the curls and waves will continually change as the head moves. To express the idea of freedom and movement you must be able to paint quickly and with confidence, and it would be useful to try out different methods of applying the paint (refer to chapter 1).

Prop a sheet of white or dark paper (to contrast with the tone of the hair) behind the sitter's head to help you see clearly the complexities of the complete shape. Do a quick sketch of the hair mass and leave the face as a simple oval shape (here I have used oil on sized paper). Try to follow the flow of the hair with a broad brush, or by wiping the paint lightly with a rag. Avoid giving a hard edge to the general shape. When you have finished the sketch, pin it up so that you can refer to it or copy from it as the painting progresses. If an interesting curl appears or a wave falls into an attractive shape, add this to your sketch for future reference.

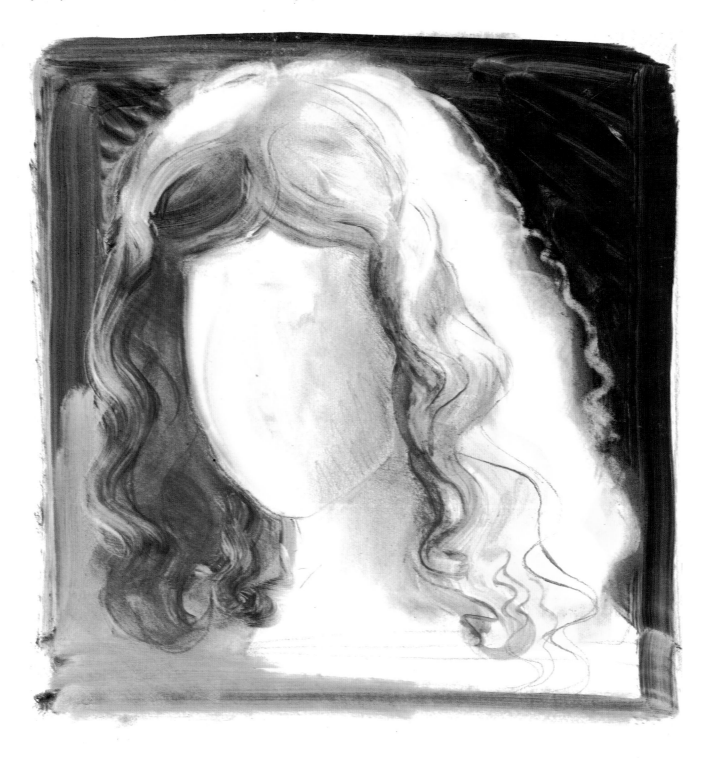

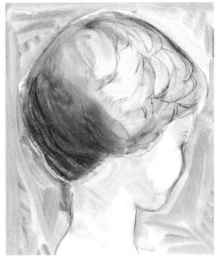

With shorter hair, try to think of the mass having a form that follows the main shape of the head. There will be a light side and a dark side. Notice how the thickness of the hair forms a shadow on the face.

Never think of the hair as individual strands but rather as a series of waves and curls, each having a definite shape.

Look very carefully for the different colours within the main hair mass, particularly the contrast in colour between the highlights and the dark areas, and note the quality of the contour.

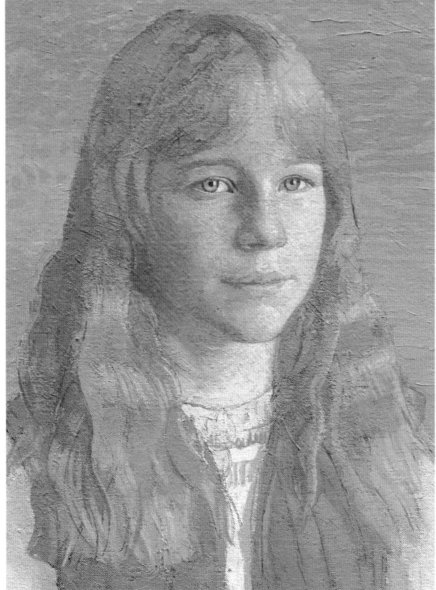

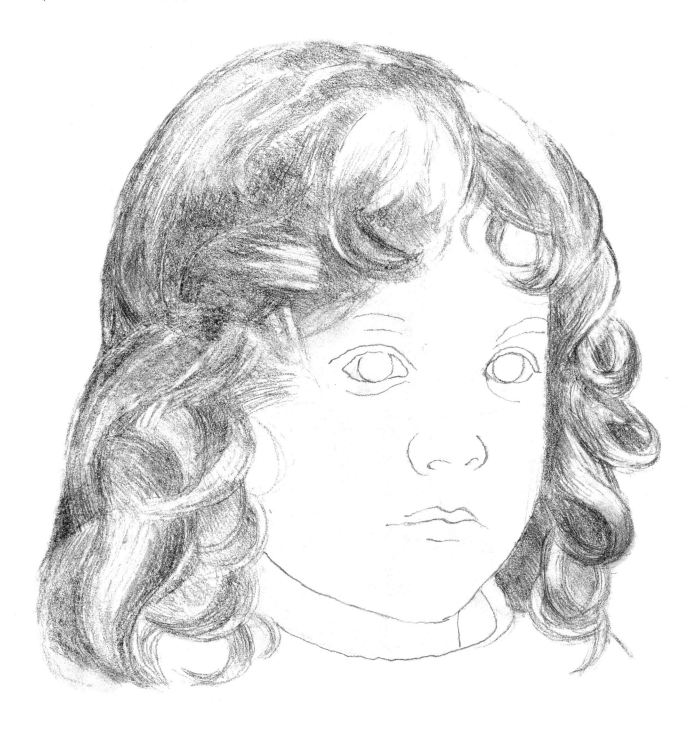

PAINTING THE HAIR

Oil paint can be applied in many different ways to suit the texture and character of hair. The thick hair in this illustration falls into very strong and positive shapes that have been carefully drawn with a pencil and organized into a flowing pattern. The face is not drawn in any detail; this con-centrates the viewer's eye on the shape of the hair mass.

This shape is first blocked in with raw umber with a little white. Each wave and curl is then thickly painted, the shapes are modelled with the brush, and the paint is scraped with a palette knife or the tip of a metal modelling tool to follow the flow of the hair.

Viridian green, yellow ochre, burnt sienna and ivory black are then added to the palette and the paint is gradually built up, referring all the time to the drawing and allowing each coat to begin the drying process. The details within the hair mass are finished and the highlights are drawn in when the face has been completed.

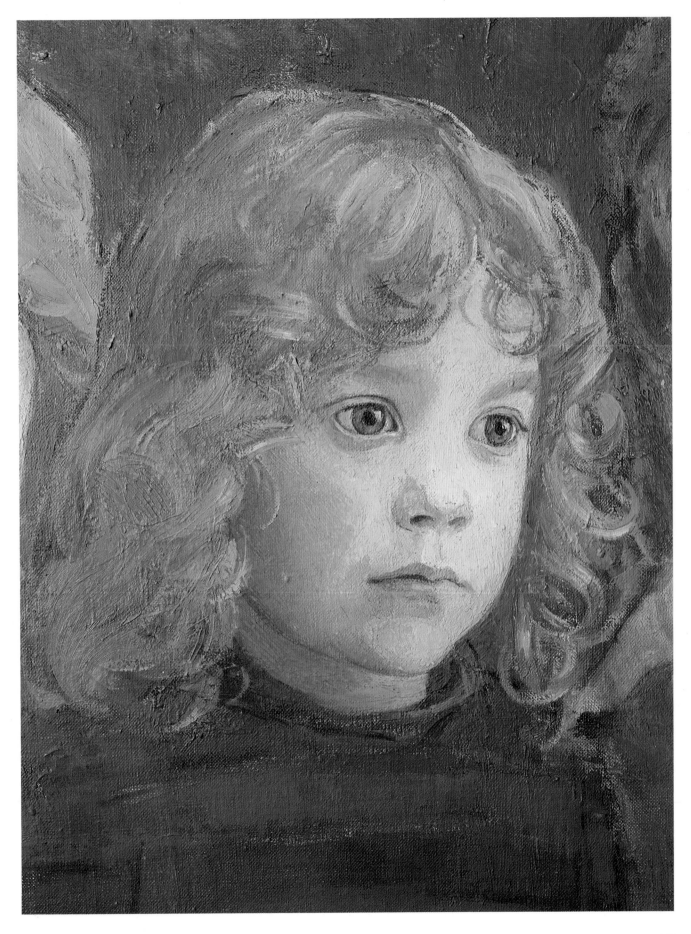

HANDS

Distinctive movements of the body, arms and hands will reveal the character of the child. Before you start a portrait, observe carefully how the hands move. Do they join together nervously? Are they active while the child is talking? Do they take refuge in the pockets, or are they displayed freely and openly? You can use the hands to help establish the pose, and encourage a restless child to remain still by suggesting that he or she hold on to a chair or clasp a toy or a book.

You can also enhance the composition, particularly for a group portrait, by the position and direction of the hands and fingers. Notice the rhythms in the composition of these four illustrations.

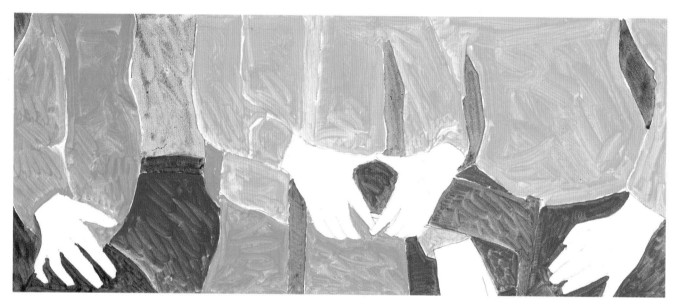

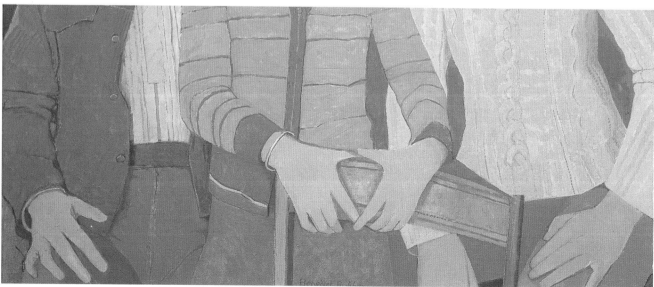

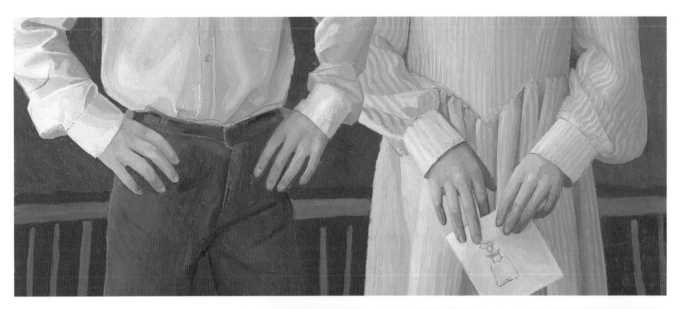

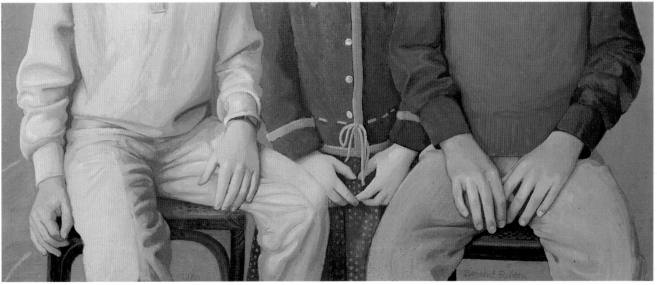

PAINTING HANDS

When deciding on a pose for the hands, avoid foreshortening and complicated positioning of the fingers.

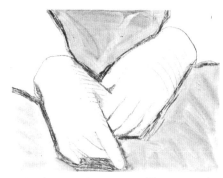

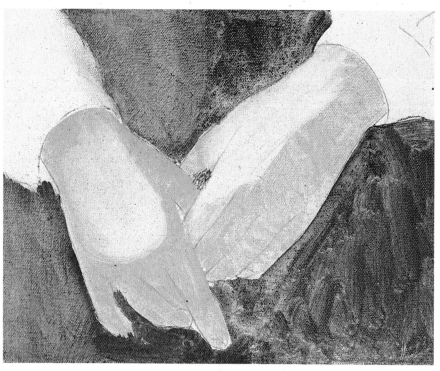

1. Make a study (you could use pencil and turpentine on sized paper; see page 18) of the main outline shape of the hands and the surrounding shapes. Note how the light and dark tones describe the form. Try to follow the form with the line of the pencil.

2. Transfer the drawing onto the canvas either by copying it freehand or using tracing paper or the squaring-up method. For this sequence I selected a palette of ultramarine blue, light red and burnt umber for blocking in the main tones. The white of the canvas was left to indicate the tone of the sleeve.

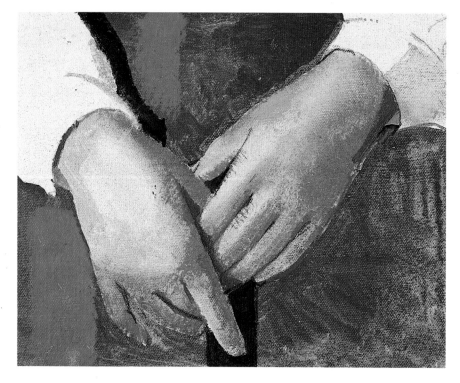

3. I then increased the palette with raw sienna, ivory black (lamp black is very strong), burnt sienna and titanium white, and established the colour of the lightest tone of the hands and the colour of the darkest tone of the blue skirt.

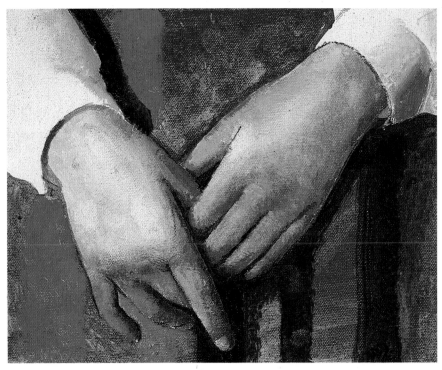

4. Note the changes in direction of plane (and therefore the changes in tone) in the hands, particularly at the knuckles and finger joints. The tones and colours have been built up within the scale of lightest and darkest established in stage 3.

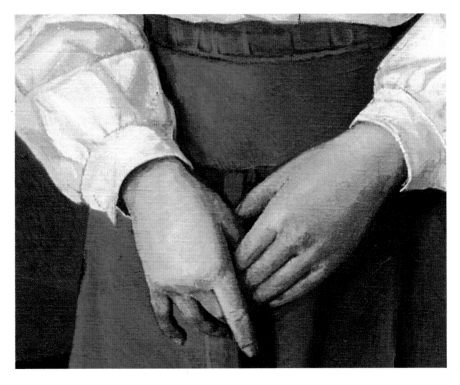

5. The painting of the sleeves and skirt has been completed, and the tones have been highlighted and details accented to enhance the form and the feeling of movement. (Note the pointing finger.)

THE COMPLEXION

The colours that make up the complexion of the skin should appear bright and fresh, so remember to select the colours of your palette carefully and do not over-mix them. The complexion of a child's skin often has a translucent quality. Try to simulate this quality by letting the base colours shine through the top layer. This technique is known as glazing. Make sure that the base colour is dry before applying the next coat. If you choose to use oil paint, apply it very thinly mixed with a drying agent. Choose your base colour (for example, it could be thinned yellow ochre or Indian red with the white of the canvas showing through). When dry, lightly rub in or paint thinly a lighter colour (try white with burnt sienna).

Block in the colour of the face and hair, paint over with your second layer and then experiment by stippling on colour either with a brush or a rag or even with your finger.

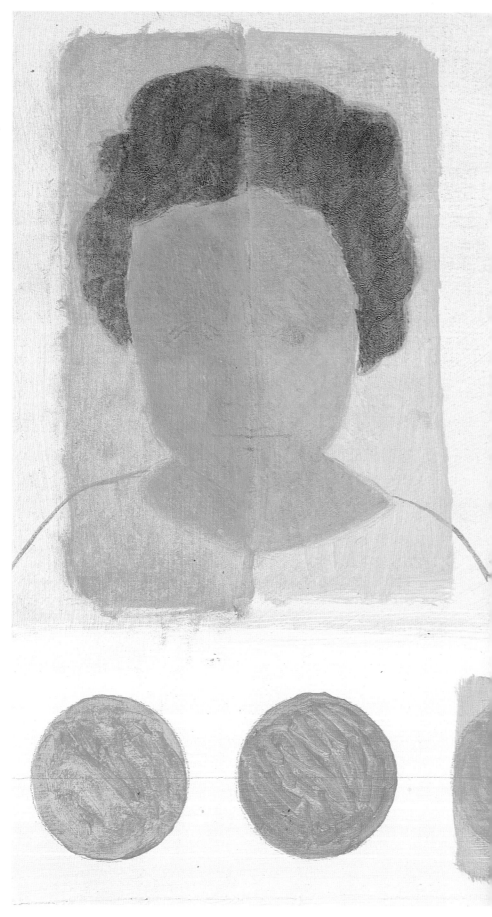

These details show how the individuality of skin and its complexion can be expressed by the application of the paint. Notice the variation in texture and colour and how this has been achieved. Start painting in the features when you feel that the area of skin has the characteristic colour and radiance.

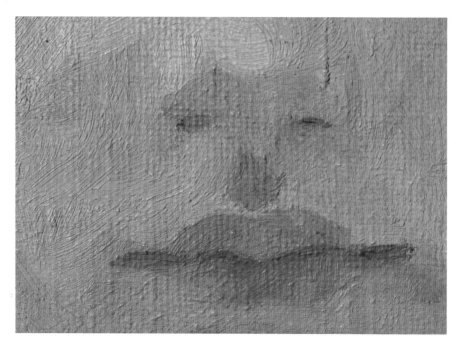

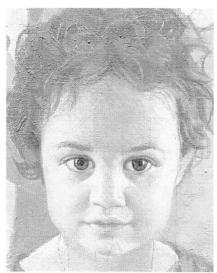

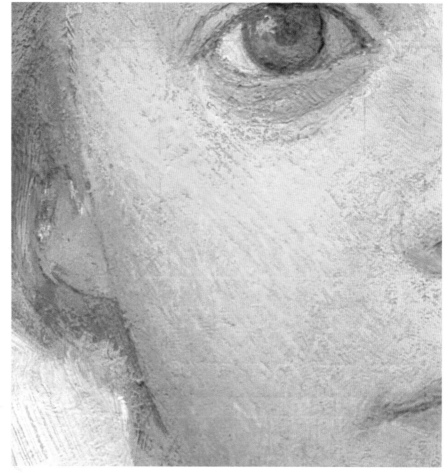

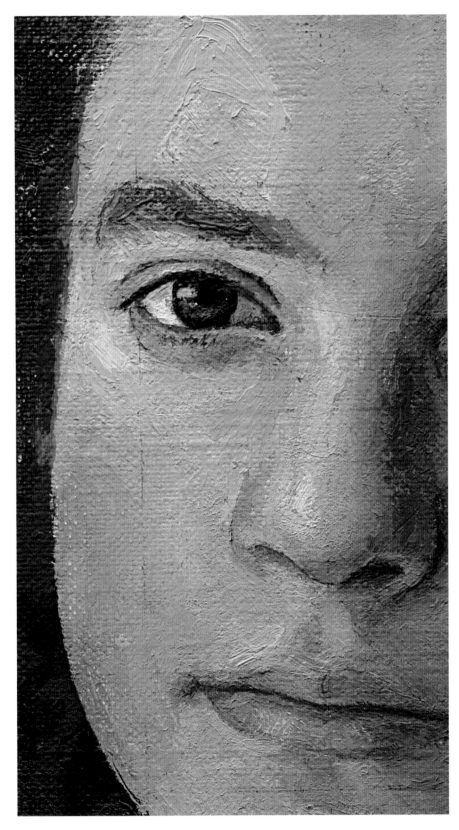

4 · POSE AND COMPOSITION

SETTING THE POSE

Choose a pose that has movement and is rhythmically interesting. It must be natural and characteristic, and one that can be sustained comfortably. If your sitter is slumped in a chair, looking straight ahead and with no turn of the head on the shoulders, your painting will also look lifeless and dull.

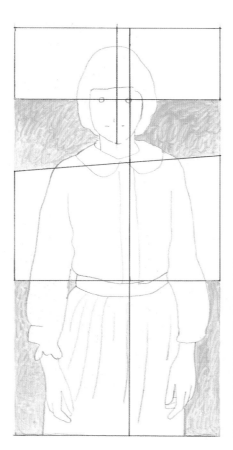

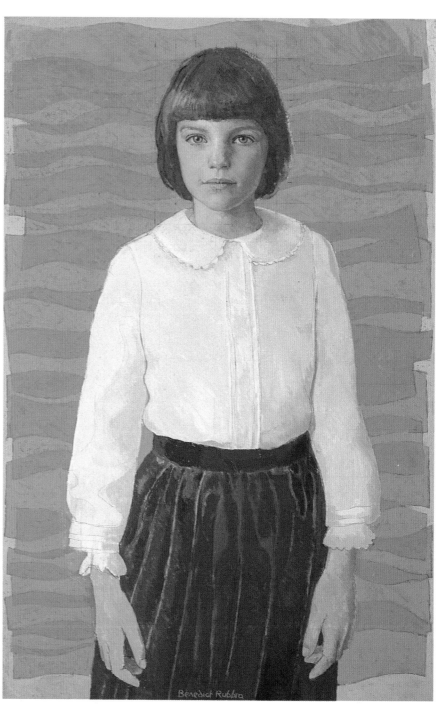

You can learn a lot about a child by noting the 'language' expressed by the subtle movements and presentation of the young body. Ask yourself if this conveys 'shy', 'aggressive', 'sensitive', 'ebullient', 'introvert' or 'extrovert'.

Note here how the head is upright and straight on in relation to the slight turn of the torso. The centre of the head is to the side of the centre of the body, suggesting a gentle sliding and forward motion. There is a relaxed dropping of the arm that also moves quietly forward with the movement of the leg. Note the position of the hands and the relative directions of the line of the eyes, the line of the shoulders and the line of the waist.

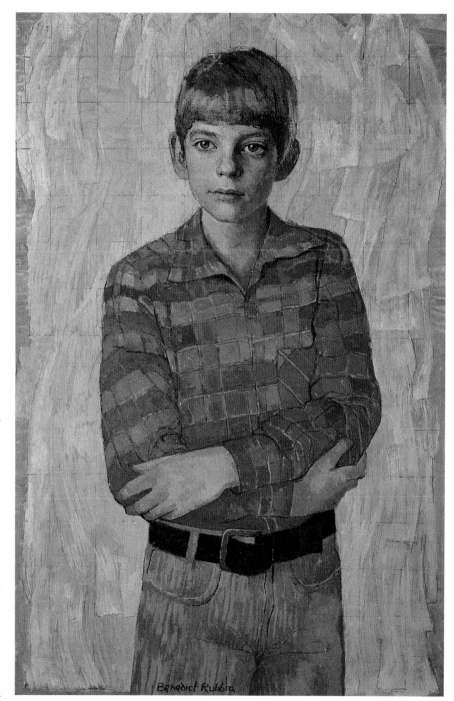

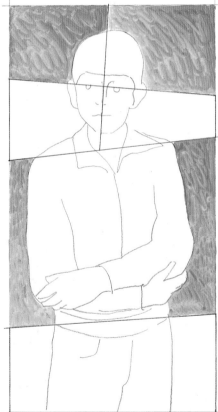

Here the direction of the gaze is counter to the direction of the shoulders, and the tilt of the head to the swing of the hips. The folded arms 'speak' differently from the relaxed arms in the first example.

DIRECTION OF THE EYES

Dramatic changes in the 'feel' of the painting or drawing can be made by the position of the eyes, so it is important to consider how the eyes are to be directed in relation to the turn and tilt of the head.

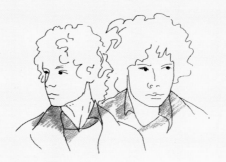

When we look at a portrait we enter it through the eyes. The viewer's eyes follow the direction of the gaze in the portrait, which either leads out of the canvas or brings him into direct contact with the child. In a group portrait an interesting contrast of rhythms is achieved simply by the way the eyes are directed. The vertical line of the standing figure is emphasized by the direct gaze, and the eyes of the seated boy give a counter movement to the composition.

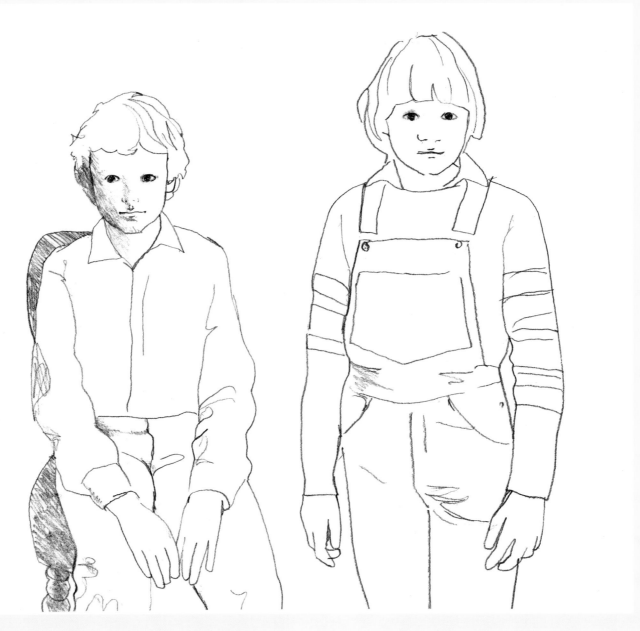

DIRECTION OF LIGHT
Use the direction of light to emphasize
the characteristic forms of the head.

Light directed from above, for exam-
ple, would accentuate the fullness of
the cheeks. Avoid too strong a light
because the forms will become con-
fused by the shadows. (Strong sunlight
entering a room can be diffused by
hanging a white sheet over the win-
dow.) A simple form will change dra-
matically according to the light that
falls on it. We can all remember as
children trying to frighten our friends
by appearing in the dark with a flash-
light shining upwards under the chin.

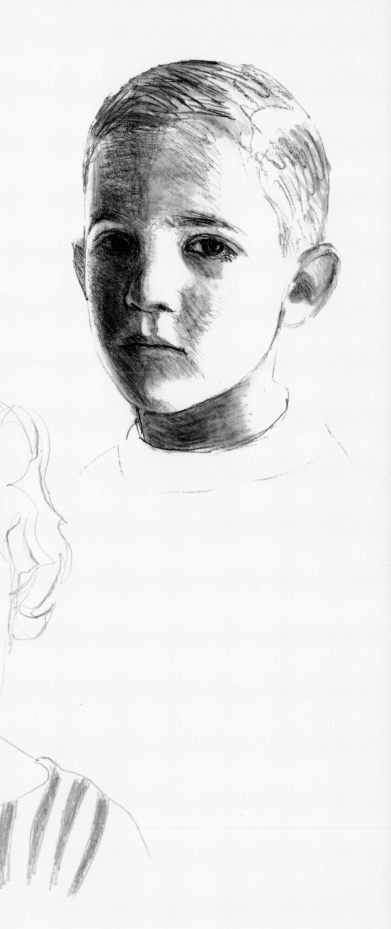

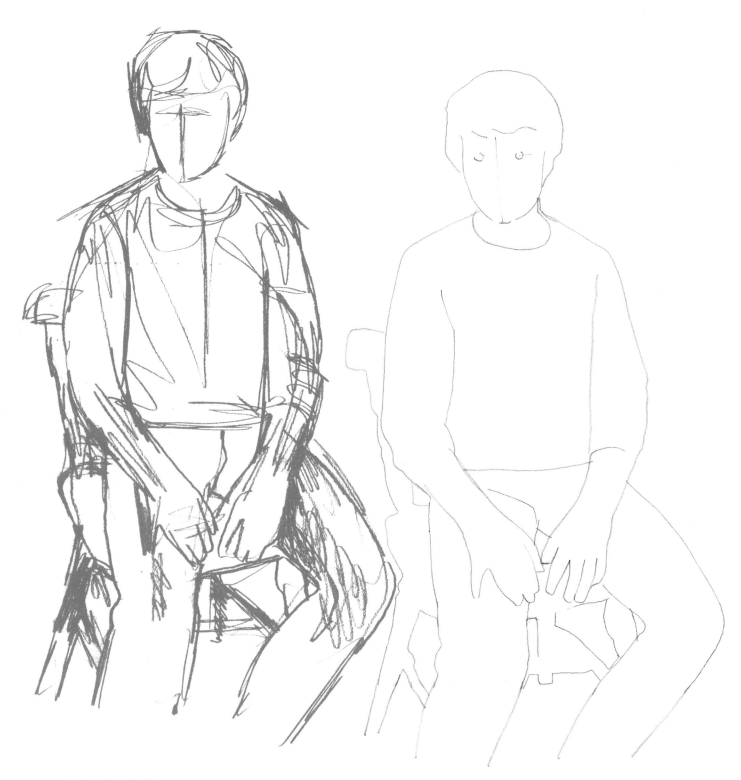

COMPOSITION

When decisions have been made about the pose, the direction of the eyes and how the light falls on the face, you now have to place the figure on the canvas to make your composition. Make pencil studies of some different poses until you feel you have the right one.

Place tracing paper over your drawing and make a simple and clear line drawing from it, adjusting the line where necessary (see chapter 1).

Cut out some cardboard frames of different sizes and proportions. (The proportion of the canvas, whether it is square or tall, should form a link with the character of the child.) Play around with different ways of positioning the frame over the line drawing. Decide how much of the figure you want to include, its position within the frame and the amount of space surrounding the figure (the background).

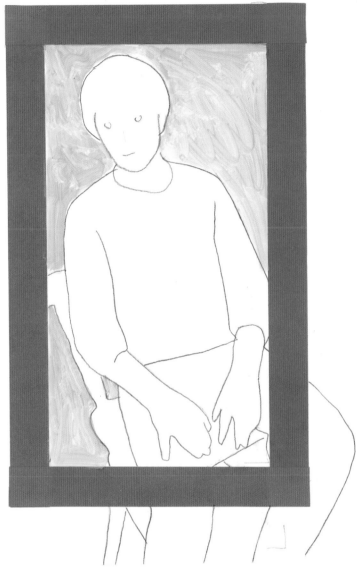

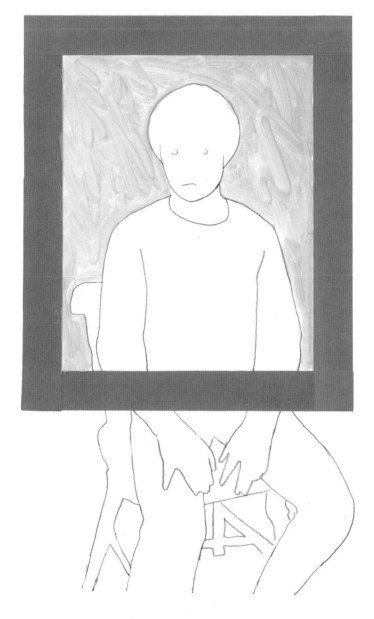

TRANSFERRING THE DRAWING

The technique of squaring up a drawing to transpose or enlarge it onto another surface is simple and very useful. It allows you to experiment freely with pose and composition. You can then transfer precisely the drawing you prefer onto the canvas on which the portrait is to be painted.

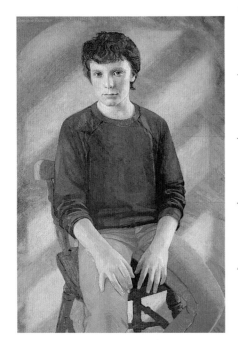

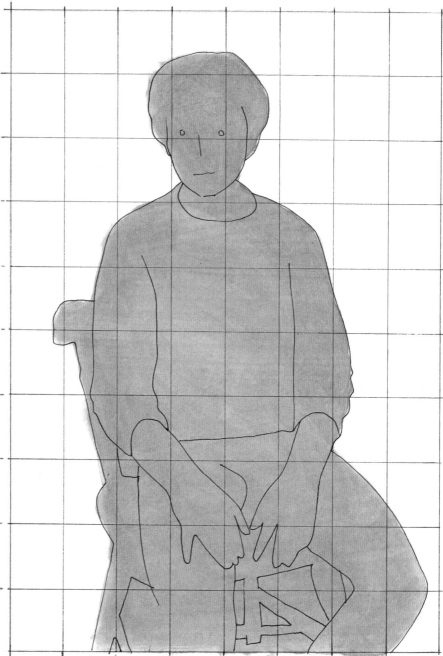

You have established the proportion and size of the rectangle and the position of the figure within it as described on the previous page. (You will find the composition and pose easier to see if you add tone to the outline of the figure.) Now divide the selected area of the drawing into equal parts horizontally and vertically to make a grid.

Place your composition at the bottom corner of a large sheet of stiff paper. Continue a line drawn through the diagonal on to the large paper. With the bottom corner fixed, a right angle drawn off any point on the diagonal line to the edges of the large paper will give you a rectangle of the same proportions as your drawing.

Prepare a canvas in these proportions to the size you want your painting, square it up with the same number of divisions as the drawing, and transfer the drawing square by square to the canvas.

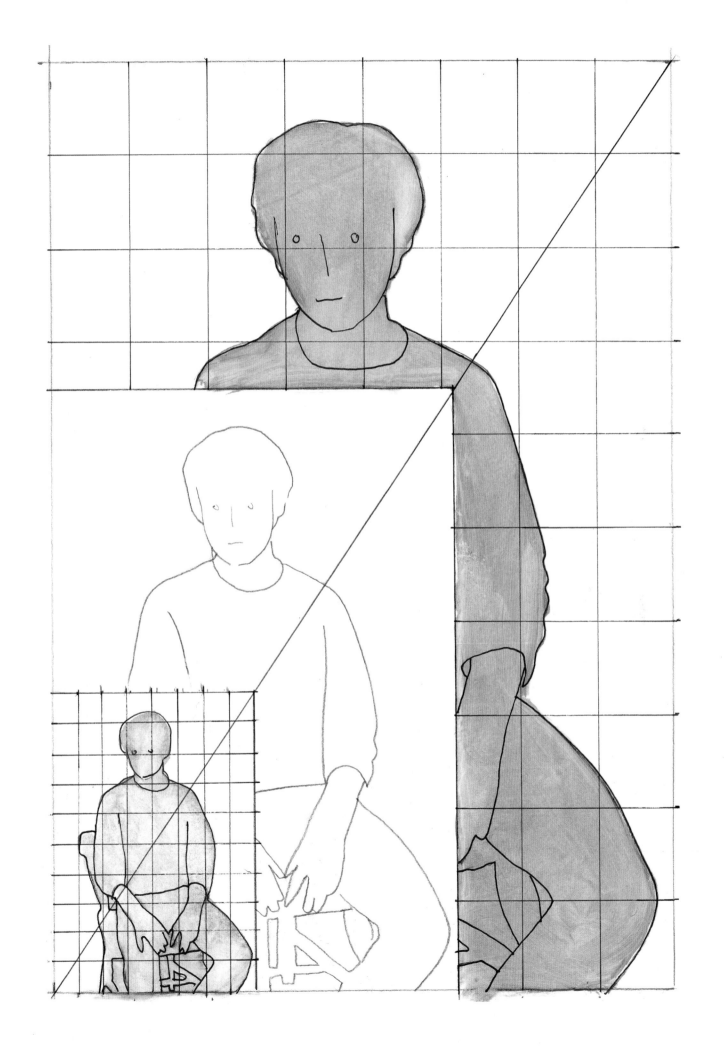

USING TRACING PAPER

We have used tracing paper for transforming a studied drawing of a head or figure into a clear outline drawing. The tracing has also been used to place over a painting as it progresses to check the contours and the correct position of the features. You can also experiment with the use of tracings for refining and improving a pose.

Make a tracing from your drawing and cut it up with scissors to separate the head from the shoulders. Move these two parts around, on darker paper, tipping the angle of the head or lengthening the neck slightly.

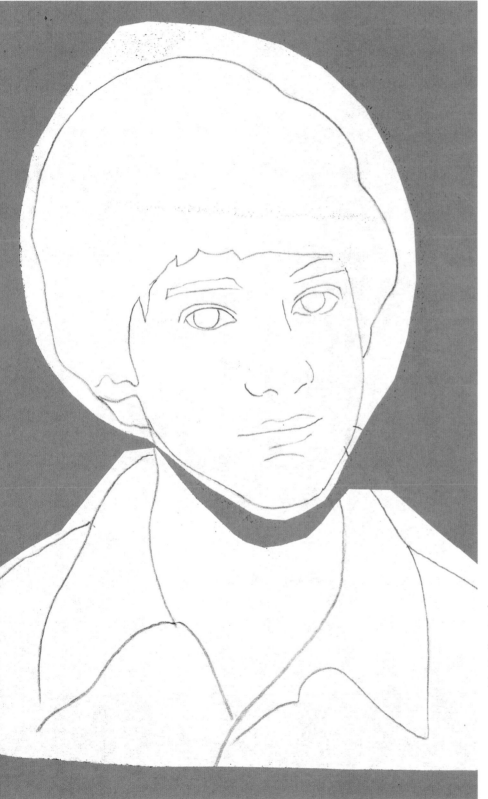

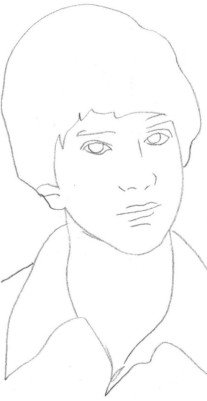

Then make another tracing from this 'collage'. You will be surprised how the smallest adjustment can produce such a marked difference in the feeling of the pose.

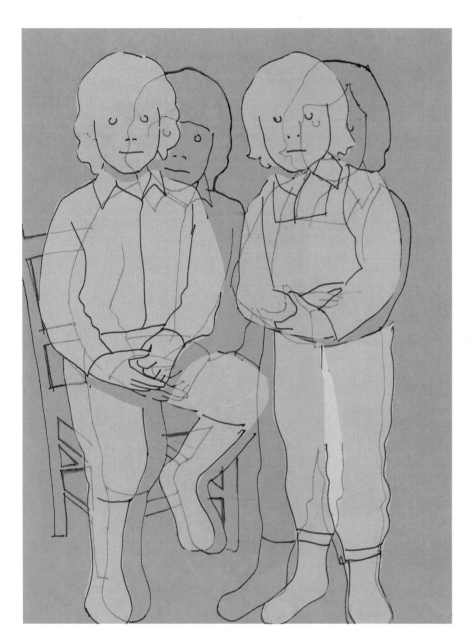

Develop this technique of cutting up your tracing a stage further. Move the pieces about to alter the position of the figures within the composition and to vary the pose. You could take several tracings from different drawings and then make a composite drawing from different selected bits. Adjusting and overlapping tracings of different figures can be helpful when designing the composition for a double portrait as shown here, or for a family group.

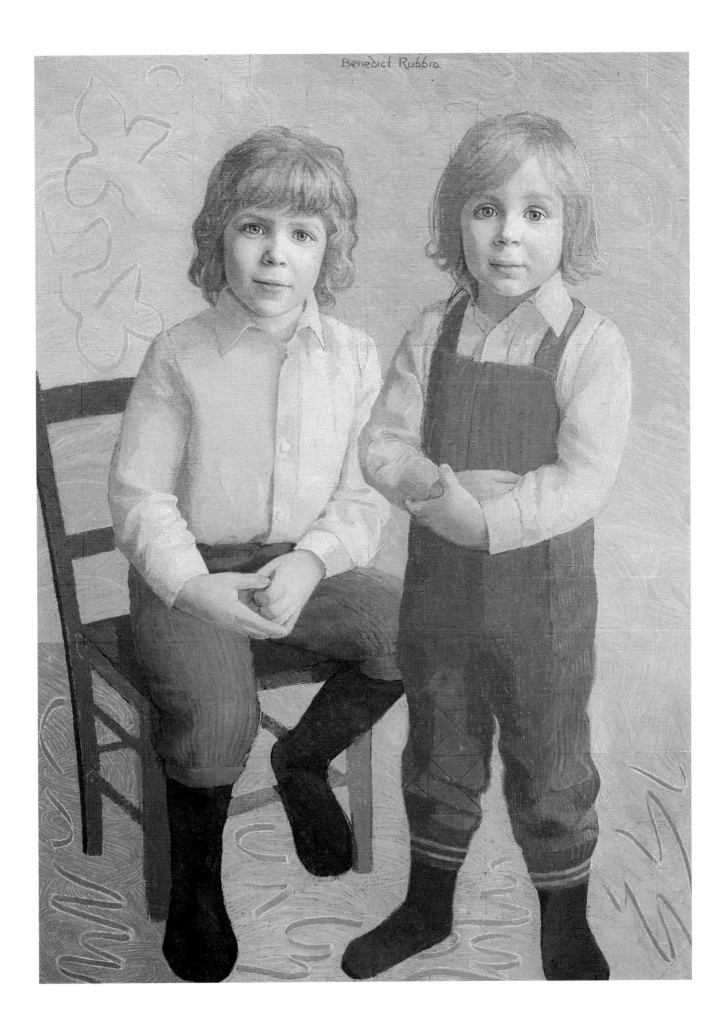
Benedict Rubbra

BACKGROUND

The space surrounding the figure – the background – plays an important part in establishing the spirit of the painting. The surface area of the background is usually greater than the area taken up by the figure and therefore this space must be filled with considered colours and shapes to introduce an exciting extra dimension to the painting. If you place a white or neutral-coloured sheet or board behind the figure, its shape or contour will be clearly defined. This artificial background should be kept behind the sitter until the painting is nearly finished. Light reflected from white paper or fabric will often produce interesting colours and tones on the face, particularly on the jaw line.

When you have decided on the composition (the size and proportion of the canvas and the position and pose of the sitter), choose a relevant colour and block in the background. This colour will influence the painting as it progresses. When the figure has been completed you can think up ideas for developing the background. One way to do this is as follows:

1. Take a sheet of paper or another canvas the same size or proportion as the portrait and paint it with a similar colour to your current background.

2. Cut out the shape of the figure from another piece of paper and place this on the coloured card or canvas. Try out some ideas around the figure.

3. Continue developing an idea until it
feels right and then transfer it to your
actual portrait, either by squaring it up
or by straight copying. If you work out
and then design the background on a
separate sheet and then transfer it, the
effect remains clear and fresh.

The different backgrounds shown here were done in this way.

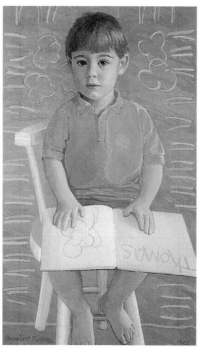

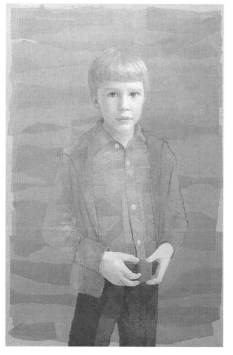

A scribbled effect used to suggest the activity of very young children.

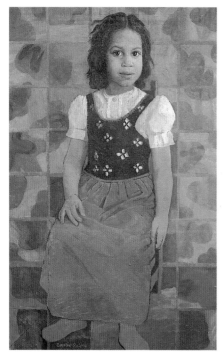

A patterned and richly coloured background relating to the type of child.

Gentle colours and lines suggesting an open space that emphasizes the character of the young boy.

Here, having decided on the basic composition and colours of the portrait, I traced the position of the figures on to a piece of paper the same size and shape as the canvas and then made a collage of squares of oil paint rubbed onto paper to form a background. This was then copied onto the portrait. The colours of each square were chosen to enhance the skin colours. Note how with the boy on the left, for instance, I have arranged dark against light, light against dark.

The flowing lines of the patchwork emphasize the rhythms of the composition, and the outer edge of squares forms a frame.

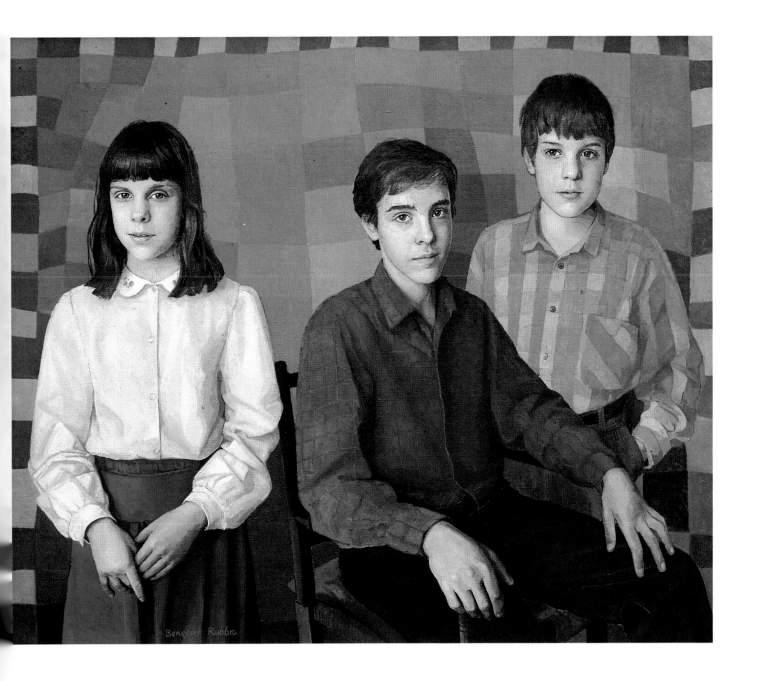

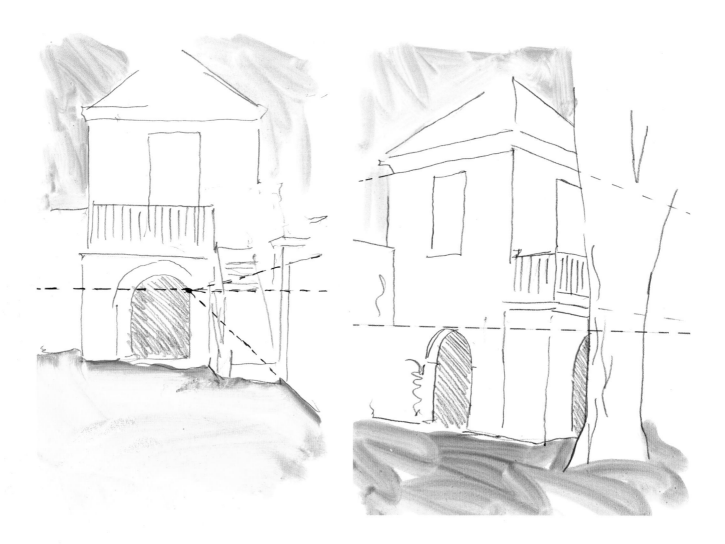

A particular background was chosen for these two portraits. First I made two sketches of the building. I wanted to position the eye level of the children at the same level as the vanishing point. (The vanishing point, in linear perspective, is the point on the horizon line where parallel lines converge. The horizon line is always on the observer's own eye level.) If the horizon line were below the child's eye level in a portrait, the child would appear to be too tall.

The pose was established (the painting was done indoors) and I then fixed the line of the eyes on the horizon line and chose a particular detail of the building.

More detailed paintings of the build-ing and different ideas of colour and texture were made on paper the same size and proportion as the canvas. The shape of the figure was left blank and in one version the shape was cut out of the paper so that I could see the paint-ing of the background more clearly. Finally the painting of the background was squared up and copied onto the actual canvas.

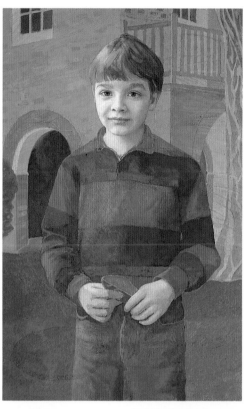

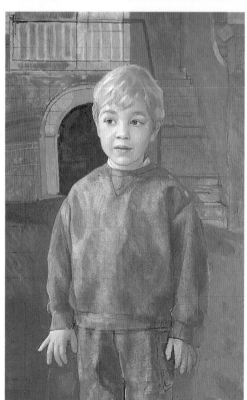

5 · THE MAKING OF A PORTRAIT

HEAD AND SHOULDERS

I was asked to paint a head and shoulders portrait of Marnie, five and a half years old, and in the following pages I shall describe stage by stage how it was done. I planned to have about six sessions with her, each lasting about an hour. Keeping relatively still for five minutes at a time is all you can expect of your sitter at this age.

My first task was to make sure that we became good friends. Between the ages of four and six a child can very quickly become apprehensive about sitting for a portrait and, if a feeling of uncertainty does set in, the working relationship between artist and sitter becomes very difficult to establish.

We talked about the clothes she would like to wear and looked for the room with the best light. (I always have as part of my equipment a white sheet that can be pinned up against the window to diffuse any direct sunlight that might shine on the canvas or sitter.) She sat on a little chair that was put on a dais (see page 43) and I began to draw in pencil, observing carefully and deciding in my mind on the pose and how the light should fall on the face (see page 83).

It is difficult for a child of this age to understand the link between the person sitting and the person drawing. To help her, I suggested she do a drawing of me (and I said I would keep very still!). Always try to make the first session as interesting as possible so that your sitter will look forward to the next.

During the next session I did an oil sketch on sized paper and thought about the general colouring (warm browns and peachy skin) and the position of the head in relation to the direction of the eyes (a direct gaze from a turning head).

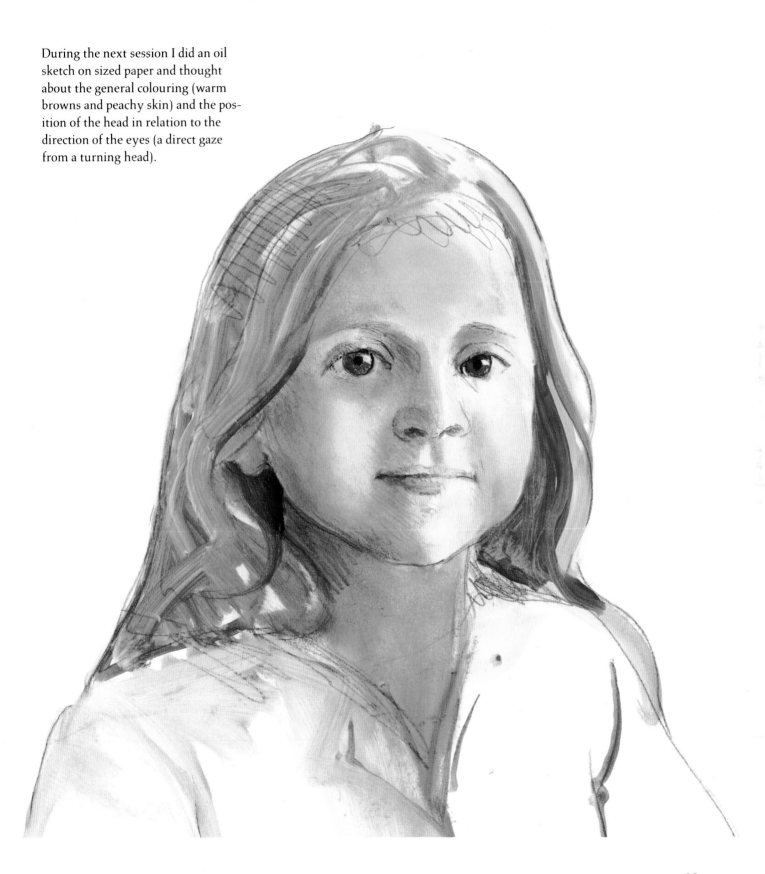

Choosing a characteristic pose is a fundamental part of painting children, so the next stage was to do some pencil sketches of three slightly different poses.

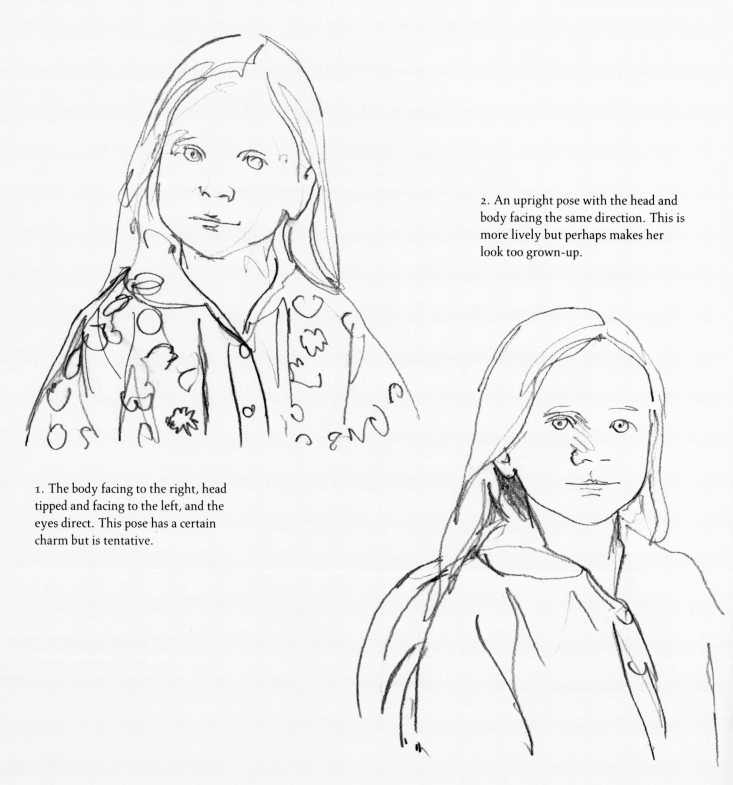

2. An upright pose with the head and body facing the same direction. This is more lively but perhaps makes her look too grown-up.

1. The body facing to the right, head tipped and facing to the left, and the eyes direct. This pose has a certain charm but is tentative.

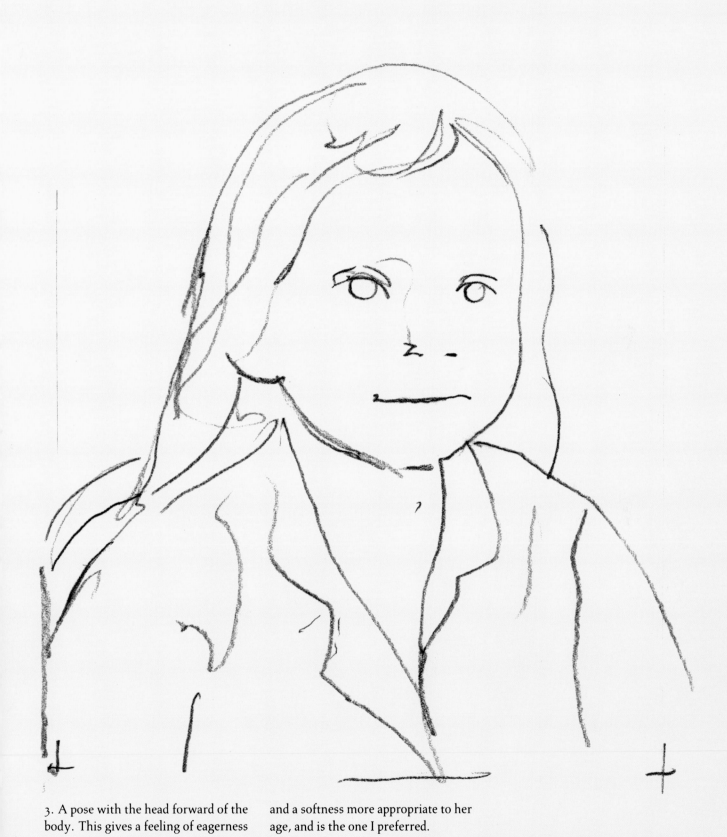

3. A pose with the head forward of the body. This gives a feeling of eagerness and a softness more appropriate to her age, and is the one I preferred.

I placed tracing paper over the chosen sketch and traced over the drawing, using a clear line and simplifying and correcting the lines of the sketch wherever necessary. I fixed the position of the eyes, nose and mouth. I then used this tracing to work out the composition, size and proportion of the canvas, as described on pages 84–5.

I find that when painting a child's head and shoulders portrait I like to keep the size of the head to about 18–20 cm (7–8 ins) high. This fits about two to two and a half times into a canvas that is a convenient and comfortable size at around 45 × 38 cm (18 × 15 ins).

I tried out different compositions by moving the tracing over rectangles of varying sizes and proportions.

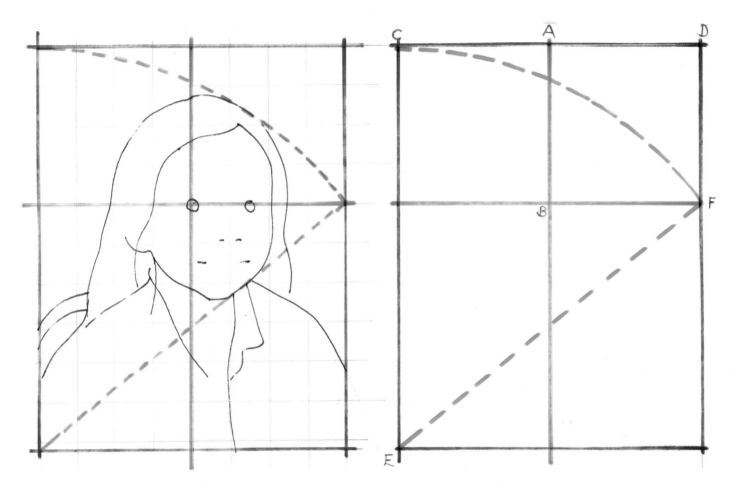

I chose one of the rectangles and then decided how to fit the tracing into it, making adjustments by moving the tracing about within the rectangle until the left eye was positioned on a central vertical line and the distance from the eye to the top was equal to half the width (AB = AC and AD). This deliberate placing emphasized the direct and positive character of the sitter. The proportion of the rectangle was finally established (and a certain harmony introduced) by making the diagonal EF the same length as the side EC. I then transferred the composition to the canvas by means of a grid (see page 86) – having first added a border for a painted frame. I felt that I needed an extra space round the figure, and decided to paint the frame as an integral part of the portrait.

A painting surface 45 × 38 cm (18 × 15 ins) was prepared by sizing very fine canvas onto board. The technique of rubbing paint in with a rag, which is ideal for building up delicate translucent colours, is best done on a firm surface that is smooth rather than rough.

This preparatory sequence can be done in the studio, without the sitter.

PAINTING THE PORTRAIT, STEP BY STEP

1. I blocked in the shape of the background by rubbing in a warm peachy colour (Mars yellow and burnt sienna) that would set the tone of the portrait and, together with the white dress, would influence and enhance the colours of the skin. Titanium white and Mars yellow were used for the light tones of the face, and white with burnt sienna for the dark tones, raw umber for the hair, and viridian and white as a base for the shadows in the dress. I drew in with a very fine brush the position of the features, referring to the tracing paper drawing. I would continue to check these positions from the drawing as the portrait progressed.

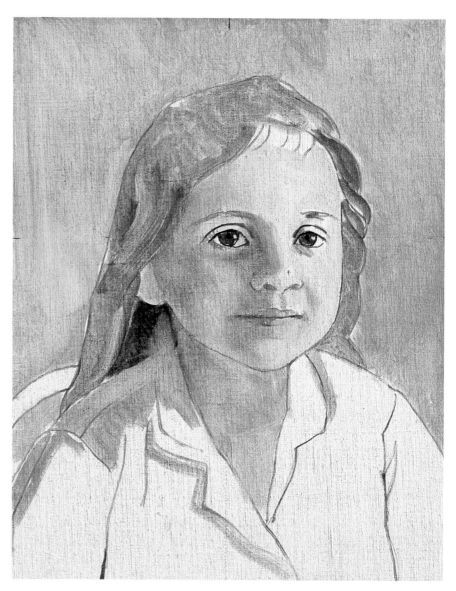

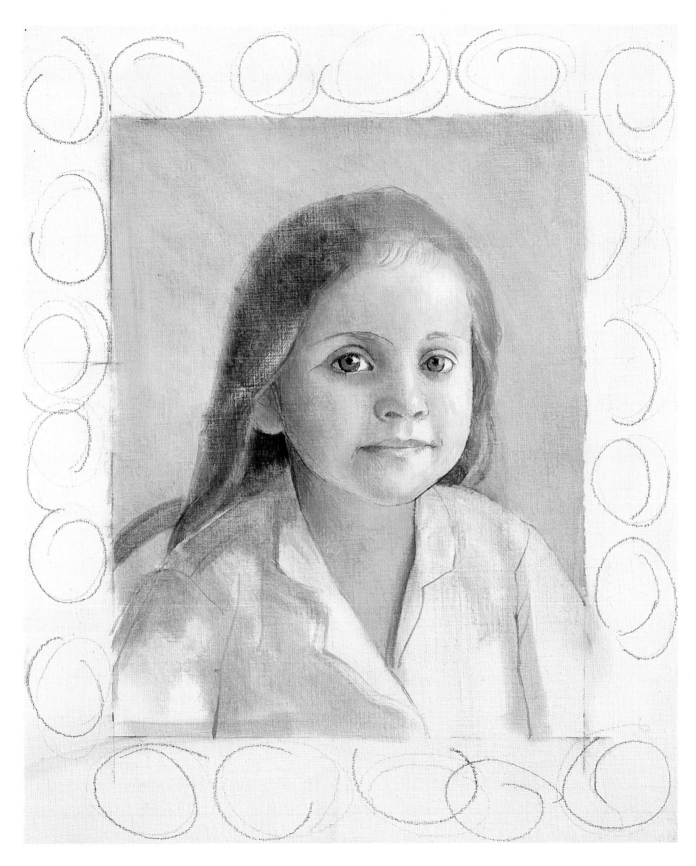

2. Keeping the same palette, I made the background slightly warmer (adding more burnt sienna) and established the darkest and lightest tones. I began to model the forms around the mouth, nose and eyes, and to try out ideas for the painted frame – perhaps a suggestion of fruit would be appropriate?

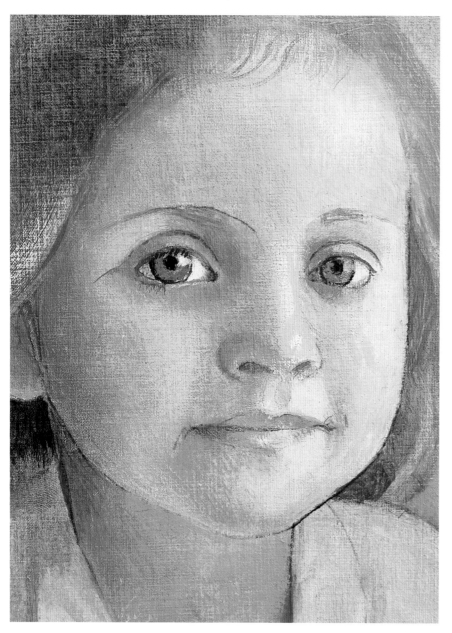

4. It was now time to view the painting from a distance. Mistakes may not be noticed when one is working close to the canvas because the eye is concentrating on the features and the individual tones and colours. If the tonal gradations in the face are wrong then the form will seem to change as the viewing distance is increased. (I know a painting is finished when it looks the same from any distance.)

I made any corrections necessary to unify the form and then concentrated on the expression: the slightly flared nostrils, the point of the chin, eyebrows almost raised, and the corners of the mouth. I had now had my six sessions with Marnie and she had had enough! So this final work was done in my studio, being very careful not to overwork the paint (which I had kept thin and transparent) and so lose the effect of freshness.

3. Having left the paint to dry for a few days (I used a drying agent), I now emphasized the reds on the dark side of the face and the yellows on the light by introducing a little cadmium red to the burnt sienna and a little cadmium orange to the Mars yellow. I painted the shapes of the eyes in more detail and settled their basic colour by bringing in the viridian used for the dress. I also continued to refine the forms of the mouth and chin and the nose. Many subtle variations within the dark, middle and light tones were made, either by rubbing and glazing or with a fine brush. Sap green with raw umber was used for the frame, and the fruit was suggested by rubbing in more of the peachy colour used for the background.

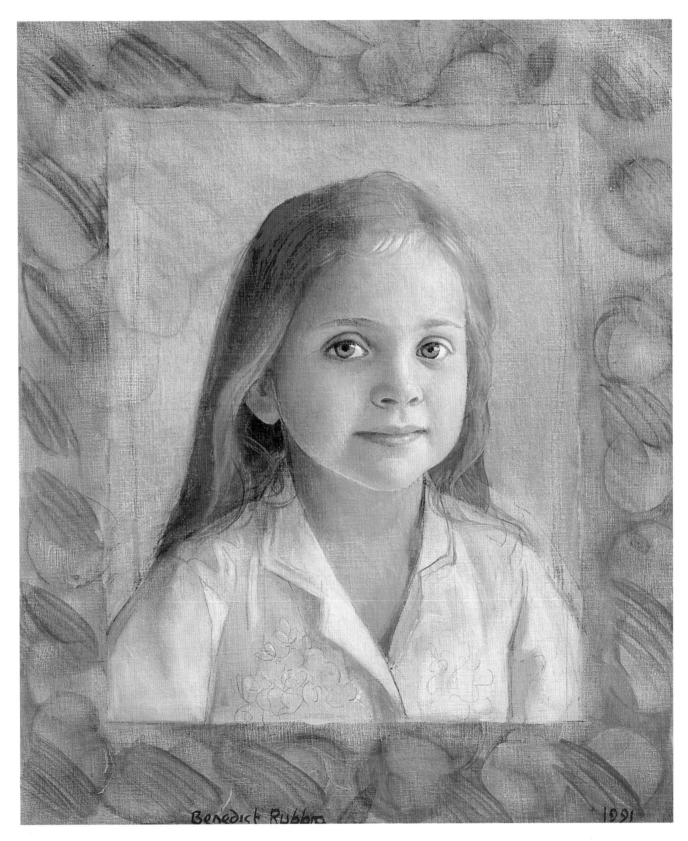

5. A final adjustment was made to the pose: I lowered the shoulder line, just a little. This small alteration of the line brought a new breath of life into the portrait, with the head now sitting eagerly on the shoulders. With this alteration made, I could now finish painting the dress, and I used a pencil line to suggest the embroidery.

A GROUP PORTRAIT

The two children in the portrait illustrated in the following pages are brother and sister, the boy aged twelve and the girl aged nine. I thought it would be an interesting idea to try to convey this close relationship of the two children in terms of composition and colouring.

The clothes were chosen so that the tones and colours would be in harmony, and the horizontal stripes add to the feeling of unity. The two blocks of stripes are diagonally opposite each other, thus adding an interest to the composition. The necklines and collars have different shapes.

A standing pose was chosen for the boy because it would express his character more clearly than a sitting pose. The slender and upright stance was attractive. Standing would suggest his wish to move away and holding onto a chair would allude to the restraint of his potential energy. I decided on a sitting pose for the girl to suggest her composure. The direction of light was selected to highlight the compact forms in the faces of both children.

Pencil drawings were made of the faces to establish the position of the features and the direction of the eyes, and

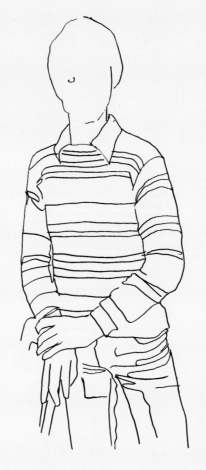

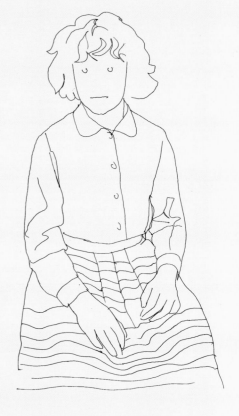

tracings made from these were used to check the position of the features as the painting progressed.

Traced line drawings were made from sketches of the pose of each child and from drawings on perspex (Plexiglas) (see page 42). The best were selected for the final pose.

Different ways of grouping the two figures were tried out by shifting the tracings about within rectangles of various proportions (*opposite*).

In (a) the difference between the two eye levels separated the heads too much and a large space was left above the sitting figure.

In (b) the relationship between the heads is much better, but the figures are restricted. The boy's arm is predominant in the centre of the canvas and he seems to be pushing himself in front of his sister.

In (c) the pattern made by the hands makes an interesting focal point. The position of the outer arms seems to unite the two figures, which are set in a freer space. This space has been blocked in with colour to clarify the composition.

The composition was then squared up ready for transfer onto a proportionally larger canvas.

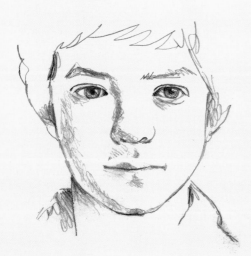

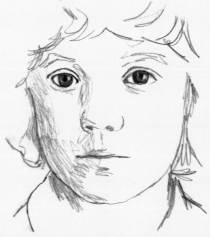

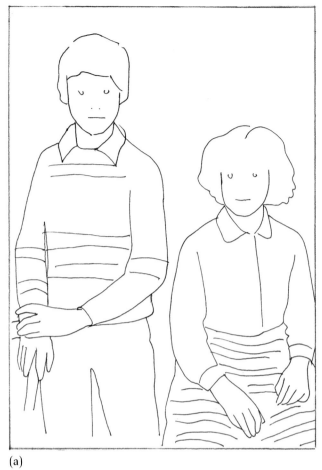

(a)

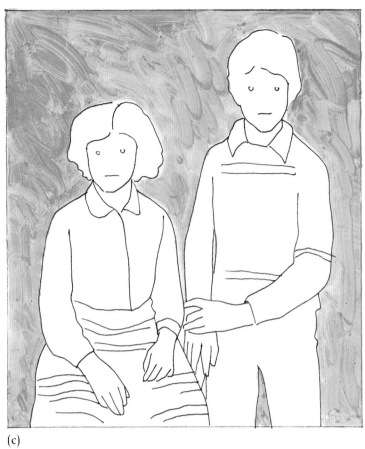

(c)

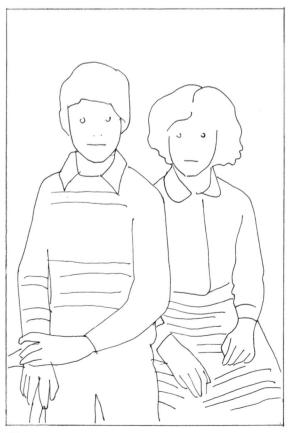

(b)

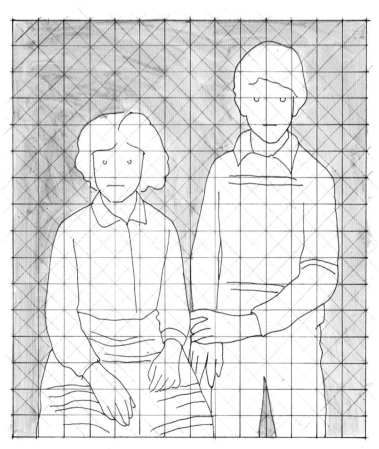

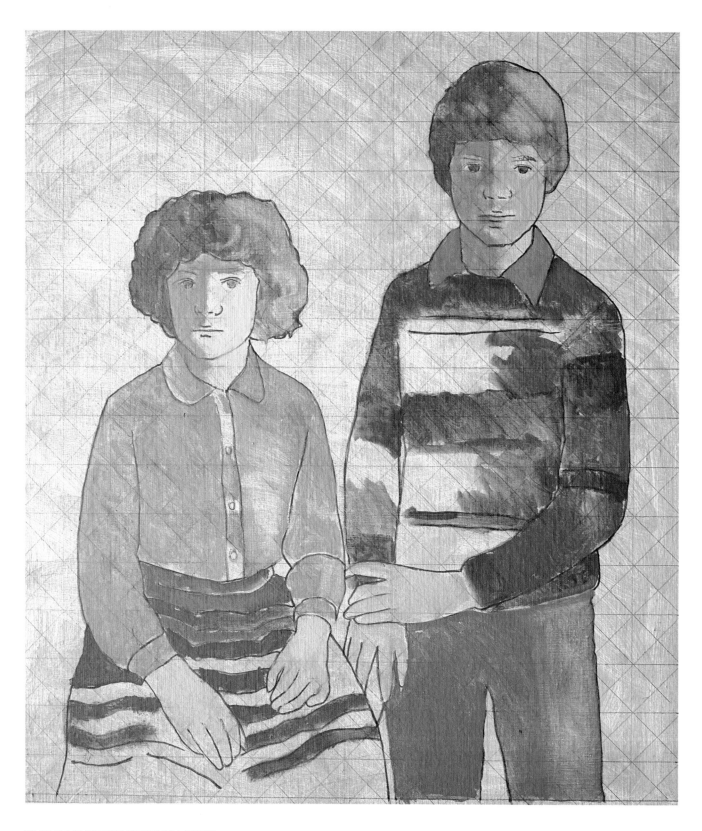

THE PAINTING STEP BY STEP

1. The canvas (80 × 71 cm/31½ × 27½ ins) was toned in with a mixture of raw umber, viridian green and titanium white. It was then squared up with pencil lines and the composition was transferred from the tracings using a fine brush with raw umber. Both heads and the girl's dress were blocked in with varying combinations of the initial palette (raw sienna, raw umber, burnt sienna and titanium white). Ivory black, light red and viridian were added for the boy's clothes and light red for the girl's skirt.

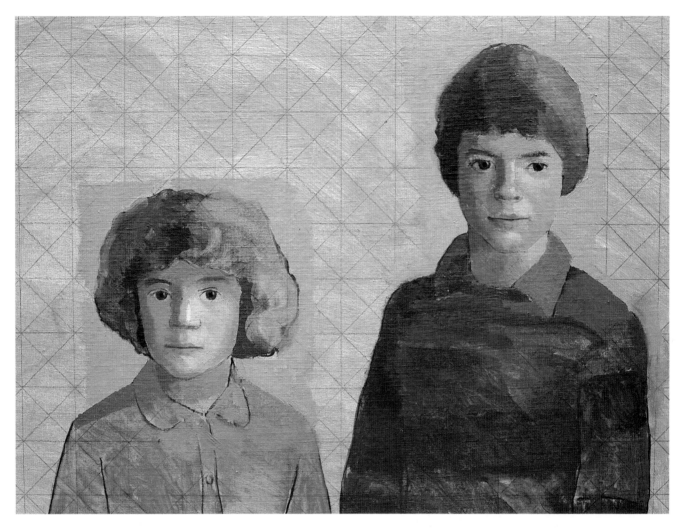

2. To emphasize a strong sense of unity in the portrait, the carefully selected colours of the palette are mainly earth colours. The colours of the darkest and lightest tones of the hair and face were fixed, and cadmium orange and yellow ochre were intro-duced for the warm light tones in both faces, completing the range. The eyes were made up of raw sienna and a little viridian green. I began to explore the colour of the surrounding background and to work out the colour of the clothes and collars. (The green of the boy's collar would influence the colour of his skin.) The paint surface of the faces was scuffled and rubbed to give the characteristic skin texture. Then the paint was left for a few days to dry.

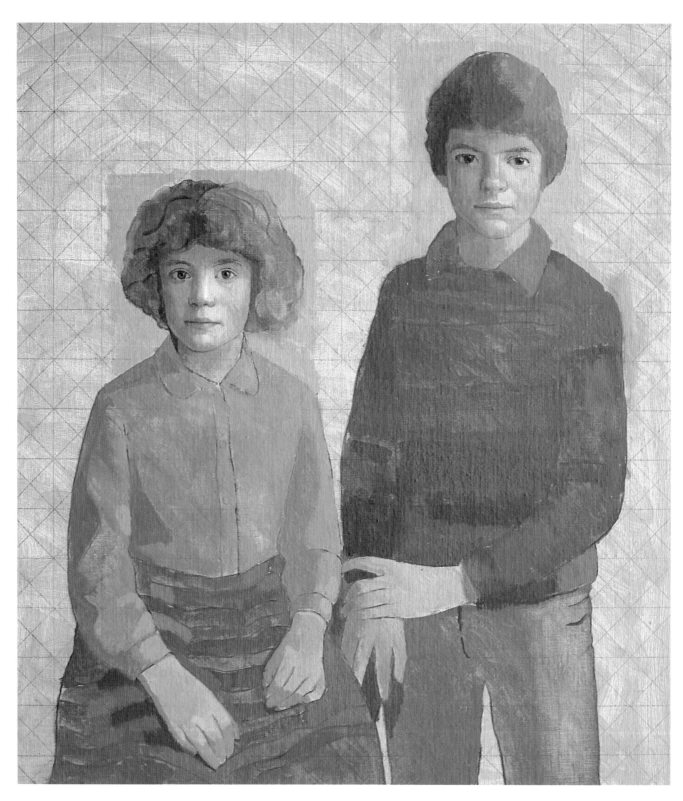

3. The shapes of the eyes, nose and mouth and the surrounding forms were carefully observed. The contour of the cheek and chin, the shape of the hair mass and the position of the features were checked against the tracing made from the drawings of the faces, and redrawn where necessary. Light red and yellow ochre were introduced into some of the flesh tones, and the main dark and light areas were now broken down into more varied textures and colours. The colours of the stripes were boldly painted in, and the shape and tones of the hands were observed and the adjacent colours worked out (no further colours were added to the palette). I made a study of the folds in the clothes and the shapes and rhythms in the hair, and blocked in the main shapes.

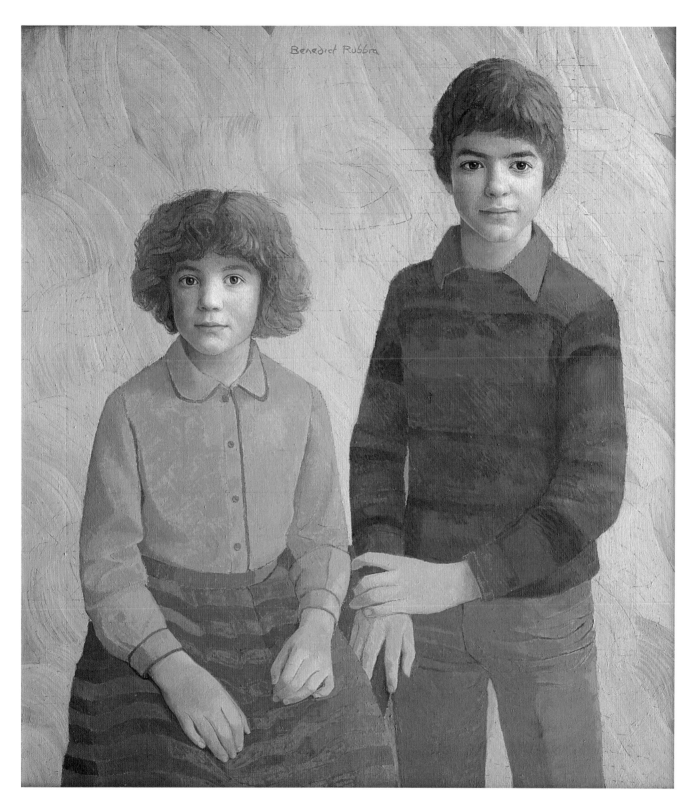

4. A sheet of paper, of the same dimensions as the canvas, was prepared and primed with white emulsion paint. A mixture of titanium white, raw umber and viridian green was applied with a broad brush. When this had dried, more paint was mixed, lighter in tone, and painted on in broad diagonal sweeps. When this surface 'felt' right it was copied onto the background of the portrait. The two figures were consolidated so that they stand out clearly from a background that has a sense of movement. The expressions were suggested, and the hair, clothes, hands and features were finalized. The forms of the hands have been kept simple so that the pattern they make is dominant. The boy's finger, just touching the girl's sleeve and placed on a central vertical line, is an essential part of the composition.

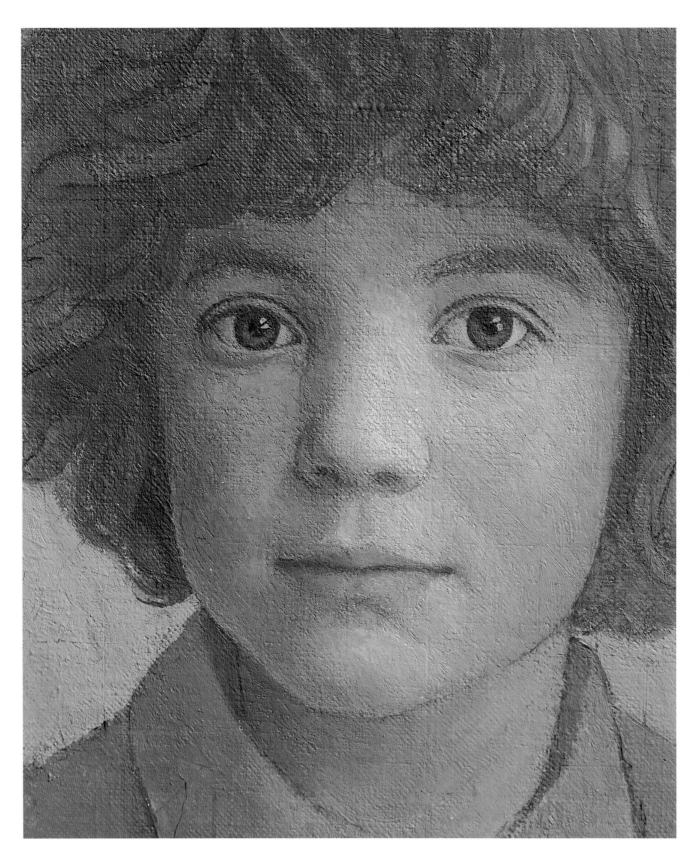

THE FACE IN DETAIL
Note particularly the texture of the girl's skin in this detail of the portrait on page 113, and the variation of colour that has been achieved from a simple palette. Look carefully at the expression of the eyes, the mixtures of colours

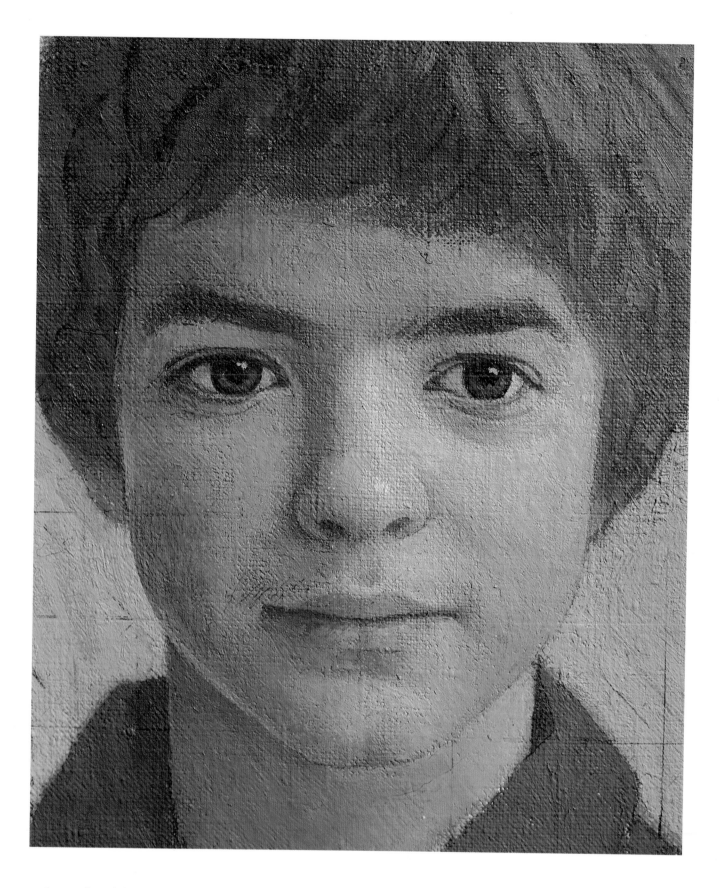

in the pupils and the shapes of the highlights. The upper lip of the boy has been very faintly marked with pencil to suggest the shadow of an adolescent moustache, so characteristic of boys of this age.

EXPRESSION

As we discovered in chapter 3, the features of the face have basic structures and forms. Different moods are expressed with each slight alteration of form, and people communicate to each other through these subtle shifts. The expression brings the form to life as water enriches the colours in a pebble.

Do not attempt to describe these subtle changes before the form is solidly understood. When the painting or drawing is well structured, you can start making the necessary slight alterations. Restraint is the keyword – it is very easy to overdo the change.

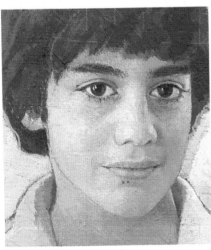

Look for the shape above the eyes (the eyelids and eyebrows), the slight accentuation of the nostrils, the corner of the mouth and the tip of the chin.

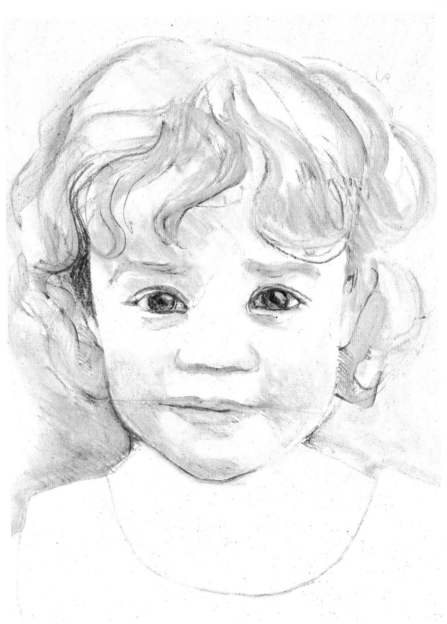

The line dividing the lips could be partially suggested and the eyes made watery by hazy definition of the iris.

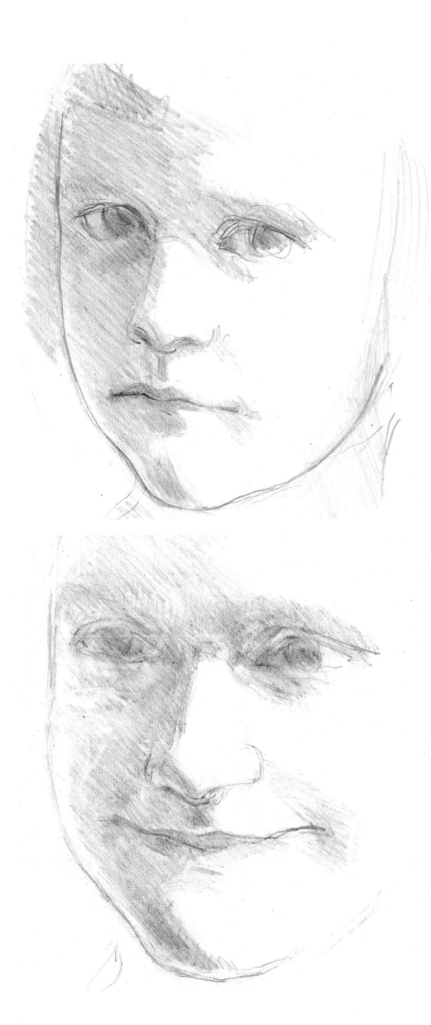

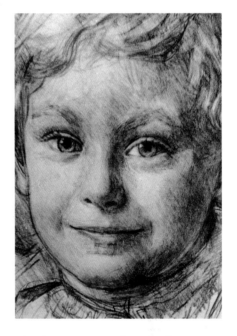

The shapes surrounding the features can be changed by adjusting the light or dark tones. Note also how the contour of the cheek and the chin will alter as the mouth changes shape.

(Refer also to the sections on eyes and mouth in chapter 3.)

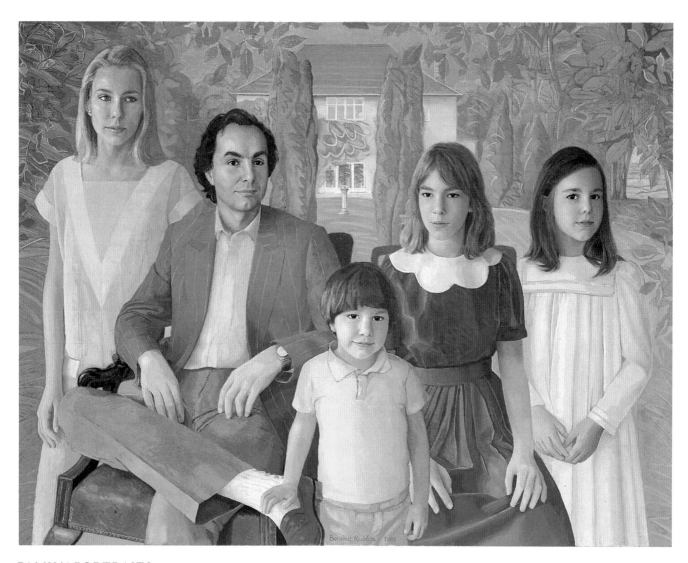

FAMILY PORTRAITS

You should approach the problem of painting a family group in the same way as painting a group of children. Treat each person individually, make studies of the characteristic poses and some sketches. (Try oil, or pencil and turps, on prepared paper. Feel free to make several attempts on the same paper – just wipe away the previous one.) Make tracings from your drawings and then start juggling them about. Shift and overlap the tracings until the individual poses, when put together, make a compact composition.

Make several cardboard frames of different dimensions and fit these over the tracings to establish the proportion for the painting. Divide the chosen proportion geometrically (see page 86) and at this stage adjust and refine the poses if necessary. You may want to turn a head so that it looks into the picture, or move an arm and hand to make a more interesting pattern.

Note the positions of the eyes and how they relate to the geometric grid, and the pattern made by their direction (here the composition is held together by the direct gaze of the young boy in the centre). Note the relative sizes and positions of the hands and the pattern they make; and also how the position of the house in the background makes a pyramid shape with the two figures dressed in dark clothes, and how the clothes alternate from light to dark across the picture.

I thought it would be useful to analyse the composition of these two group portraits to see how an extra 'dimension' can be given to a painting. The way the figures relate to each other on the canvas can express character and also the relationship between each of the children.

With the three children, the composition is compact and expresses the idea of a close relationship. The canvas is almost square, with a central figure, and the three heads are brought close together. Note the diagonals and how the two outer heads fit into the triangle formed by them. In this group there is much less background area in relation to the figures than in the one opposite.

With the portrait of the two boys the emphasis is on the rhythm, and their individuality is given expression by the space surrounding the figures. The energy of the standing figure and his compact body contrast with the quieter mood of the seated boy.

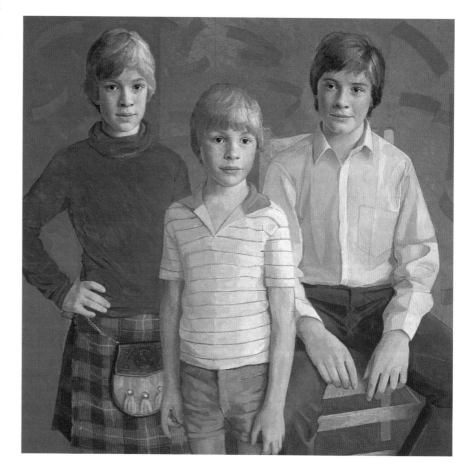

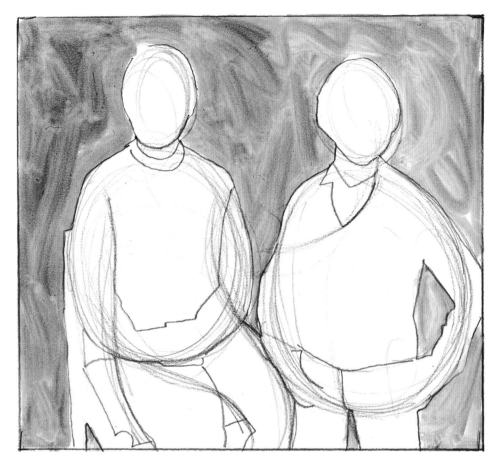

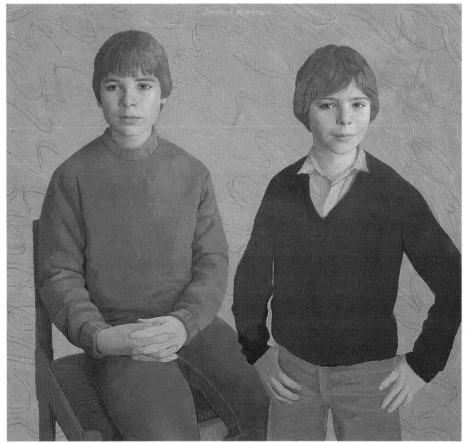

In this portrait, the individuality of each character is important, with a strong emphasis on the mother as the nucleus of the family.

6 · SOME FINAL ADVICE

RACIAL CHARACTERISTICS

Throughout the world, wherever a child may come from, the spirit of childhood is a common factor. Energy and spontaneity, freshness and brightness, are innate qualities that must be expressed in portraiture. There are, however, subtle differences in the bone structure, complexion and poise (how the body moves) of children of different racial origins.

Look carefully at the shape of the features in different types of face – eyes, cheekbones, nose, mouth – and at the distances and shapes between them, the width of the face, and the shape of the head. Be aware of these characteristic forms but be careful not to overstate them.

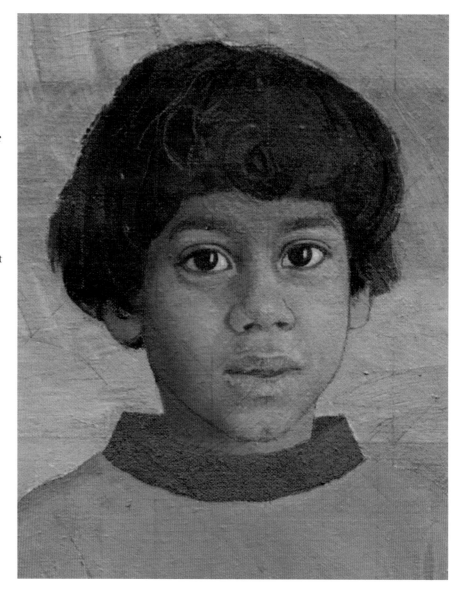

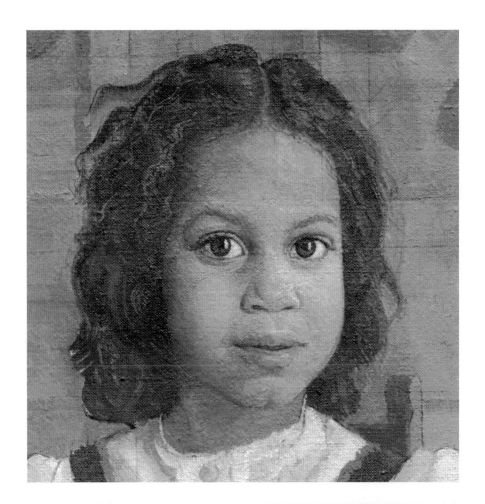

Choose one of the techniques outlined in chapter 1 that you feel is the most appropriate way of expressing the texture of the skin. Keep the initial colour palette simple (three colours and white). Remembering how colours can influence and enhance each other, make a deliberate choice about the ground colour of the face and the background.

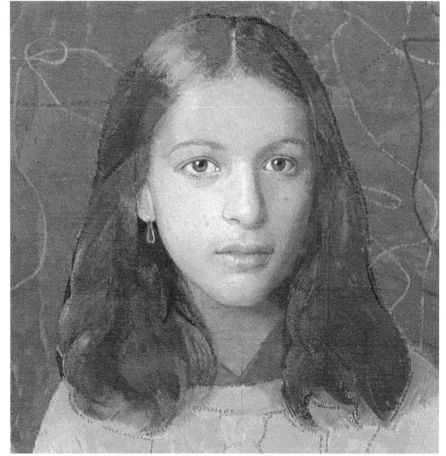

CLOTHES

Before you start making the first
sketches and preliminary drawings for
a portrait, make sure that both you and
your sitter are happy with the clothes
that are to be worn. A child will be
more at ease in familiar, informal
clothes. Try to avoid complicated pat-
terns or bright and discordant colours
that will distract from the simple forms
of the figure.

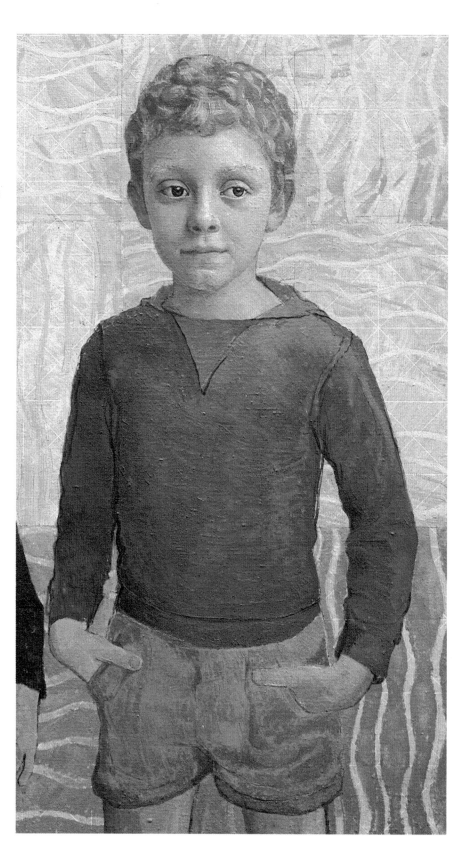

A plain-coloured and close-fitting gar-
ment will indicate clearly the shape of
the body.

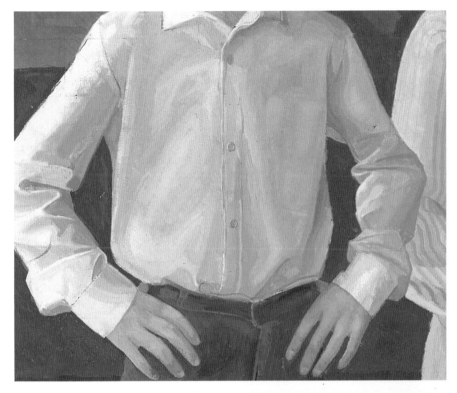

Choose particular items of clothing for coloured sketches or drawings of children in action. A hat, for example, would suggest that the child is out of doors. This drawing was done with pencil, oil pastel and turps on prepared paper.

The representation of the body and the clothes may cover a large area of the canvas and therefore this space should be interesting to look at and to paint. A plain cotton shirt, for example, falls into attractive folds but is not complicated or distracting. Establish a clearly defined shape and then block in with the general tone and colour. Do this as soon as possible, because the colour of the clothes will influence the colour of the face. A cold green, for example, will accentuate pink tones in the skin. Treat the folds of fabric in the same way as described for painting hair on page 69. The shapes of the folds, like the shapes in the hair, will continually change. Make some studies of these folds, noting carefully the shapes and colours of the light and dark areas.

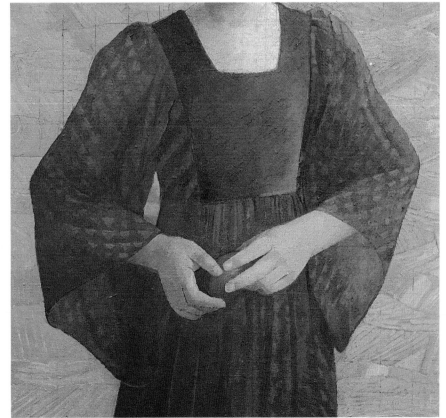

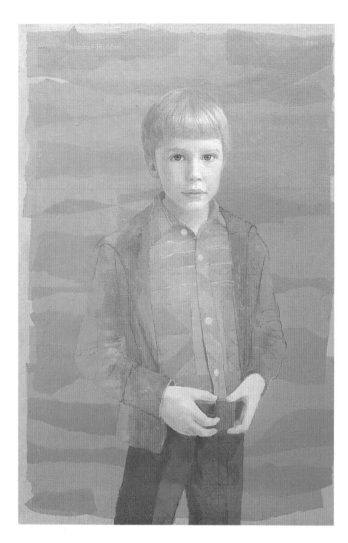 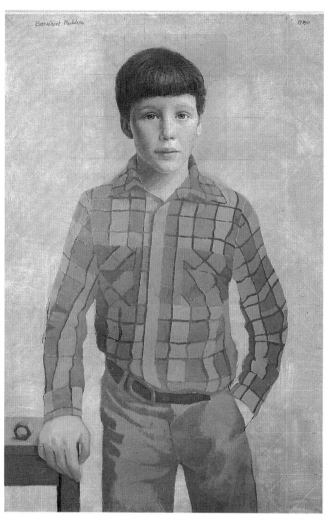

AGE

There is no precise age when childhood begins and ends. The transition from baby to child and from adolescent to adult is gradual and imprecise. In child portraiture, three and a half years is about the earliest practical age for a painting, and sixteen is about the limit at the other end of the scale. The middle age range, between six and twelve years, is ideal. But whatever the age, the child's fundamental character remains constant; it is the emphases within the character that shift during the development from childhood to adulthood.

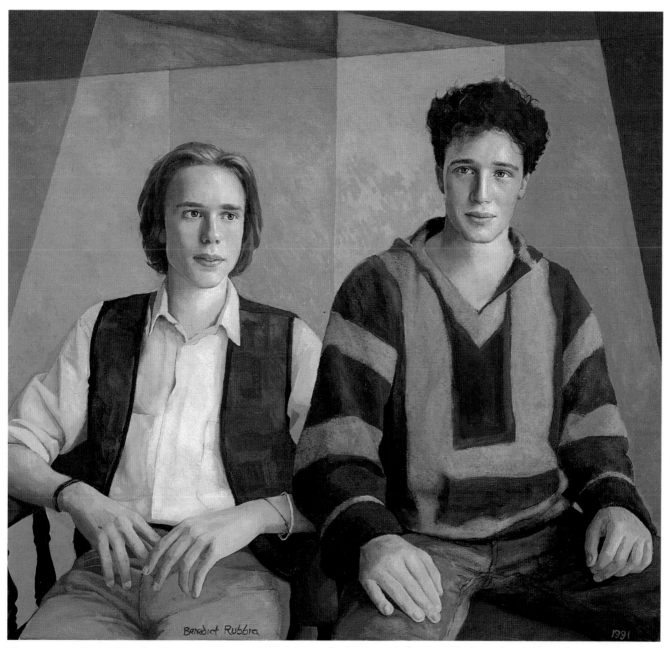

There was a ten-year gap between these portraits of two brothers. The joint portrait was not deliberately posed to relate to the first two, but it is interesting to notice how the posture, the position of the hands, and the clothes of each boy relate to and are echoed in the later one, conveying the consistent development of character.

The progression from infancy to late adolescence

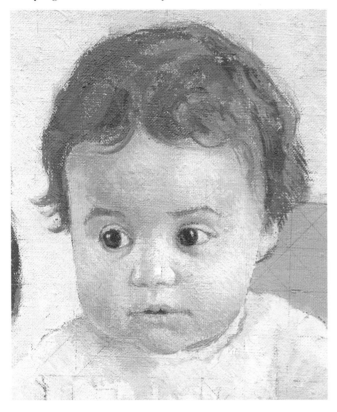

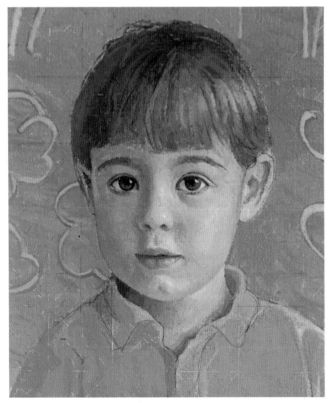 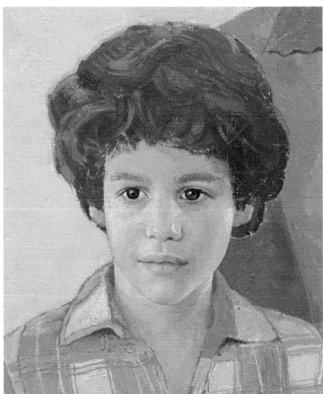

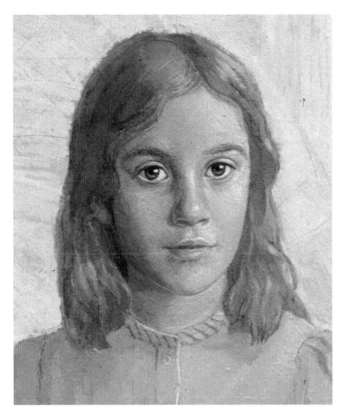
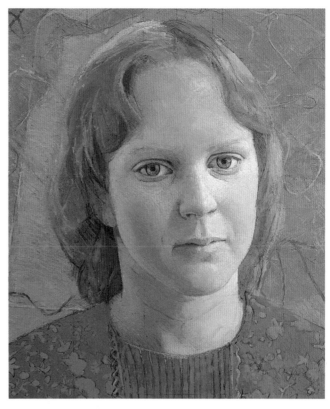
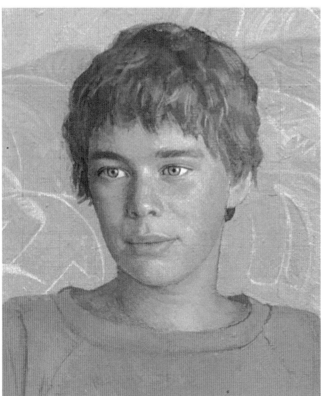
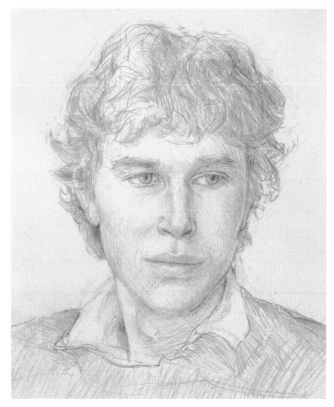

A boy growing up.

These four portraits of the same boy
show how the forms and proportions
change as bone structure and facial
muscles develop.

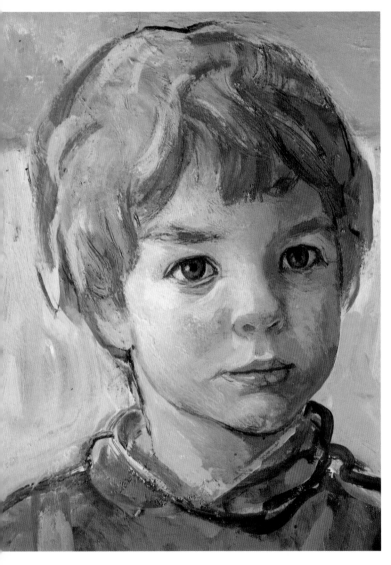

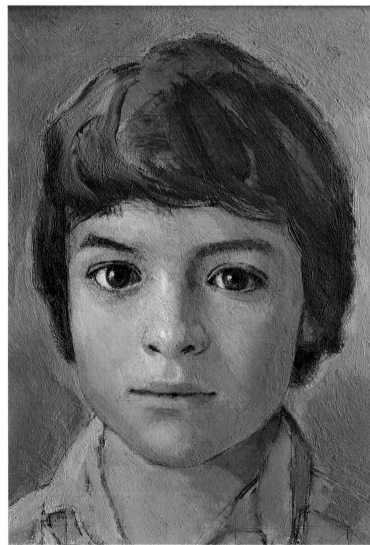

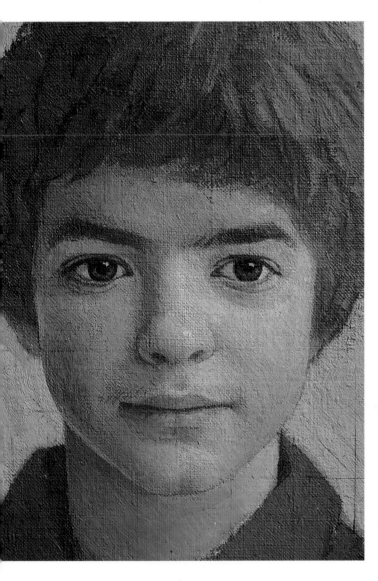

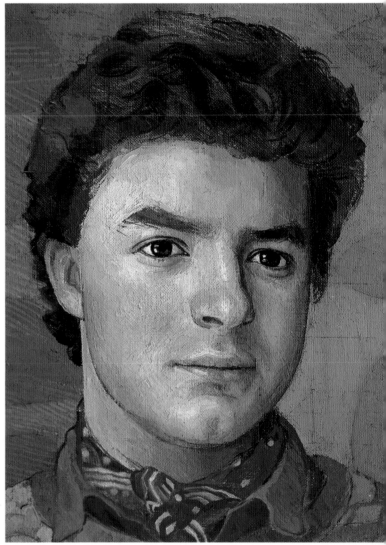

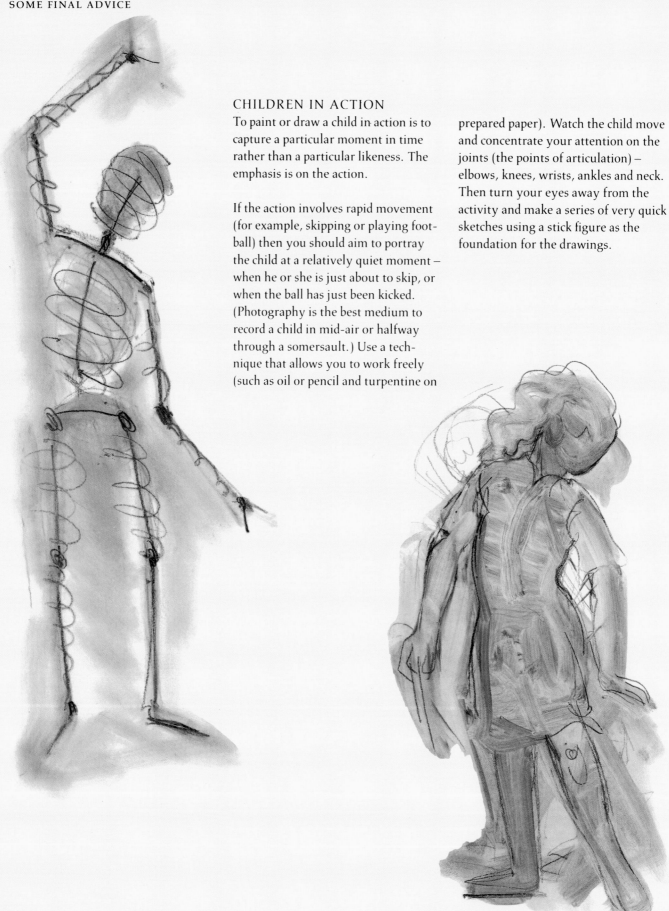

CHILDREN IN ACTION

To paint or draw a child in action is to capture a particular moment in time rather than a particular likeness. The emphasis is on the action.

If the action involves rapid movement (for example, skipping or playing football) then you should aim to portray the child at a relatively quiet moment – when he or she is just about to skip, or when the ball has just been kicked. (Photography is the best medium to record a child in mid-air or halfway through a somersault.) Use a technique that allows you to work freely (such as oil or pencil and turpentine on prepared paper). Watch the child move and concentrate your attention on the joints (the points of articulation) – elbows, knees, wrists, ankles and neck. Then turn your eyes away from the activity and make a series of very quick sketches using a stick figure as the foundation for the drawings.

Put tracing paper over the sketches and make a clear line drawing, adjusting where necessary. These tracings can now be used as a basis for another study or to make up a composition of children playing.

Watch the child again and now draw the movement without looking at the paper. The result will look like a scribble, but you will be learning to make the pencil 'become' part of your eye. Do this as often as possible. It is a very good exercise.

Action can also be expressed by painting or drawing the child doing something that does not involve vigorous movement – for example, reading or drawing, listening or resting. Again the emphasis is on the 'action' rather than on the face and a specific likeness. Look for the movements that are particular to children. For instance, when a child reads or draws at a table, the head is bent down right over the paper; or children will often read lying on their stomachs with their feet in the air.

Either make some flowing line drawings while the child is occupied, or deliberately pose the child in a more sustainable position.

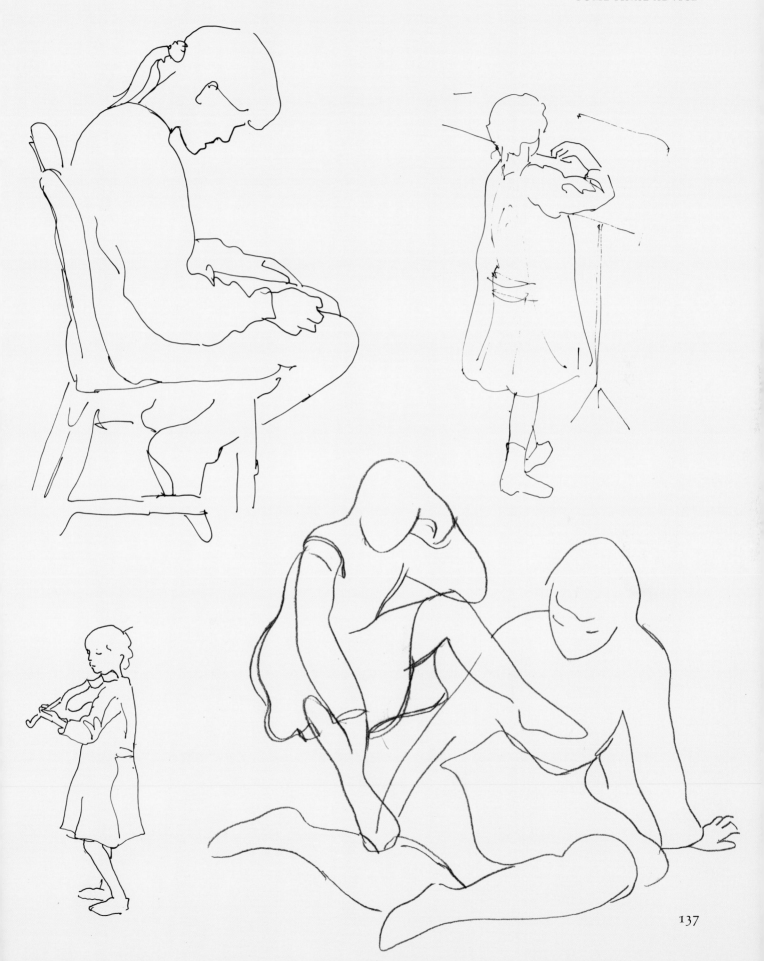

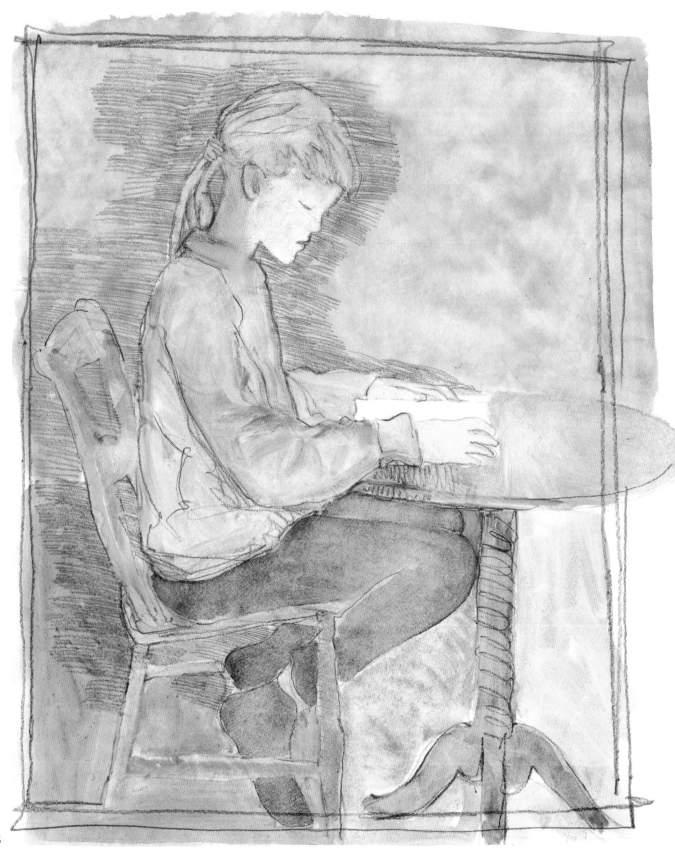

Draw or paint the full figure and place
the hands and feet so that they can be
seen clearly. (I have used oil and pencil
on prepared paper here.)

A young child will often like to pose
with a favourite toy.

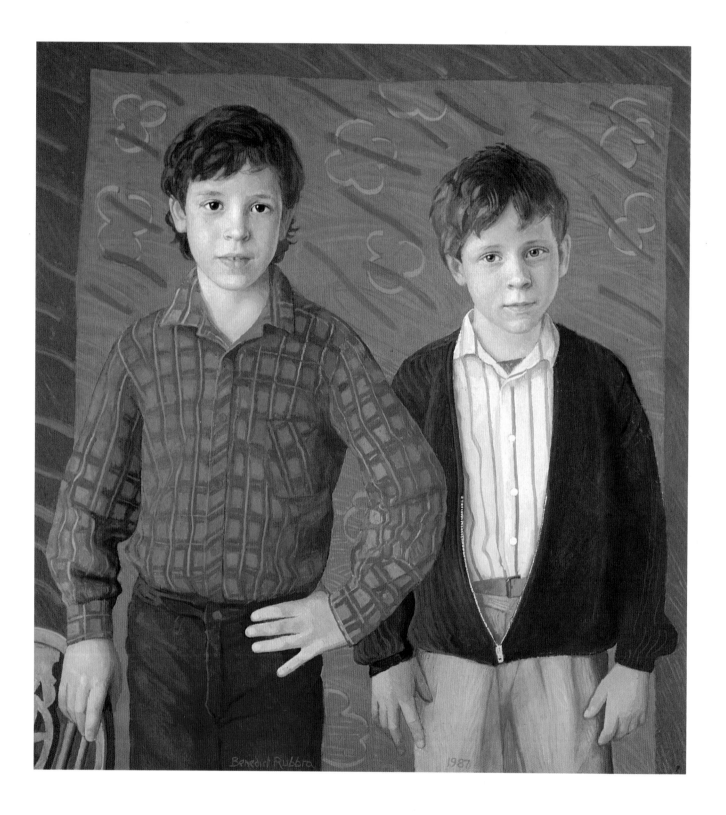

CONCLUSION

I hope that the last pages of this book will mark the beginning of an adventure. On each preceding page there are ideas that should form a solid base from which you can find your way into the fascinating area of painting children. But of all the ideas that have been presented to you here, the most important must be the conviction that your eyes have to be finely trained to search out forms, colours and contours. Even when you are not painting or drawing, try to see the things around you in terms of shapes that you feel you could describe on paper. Look for relationships in colour – the lemon against the side of the bowl, or the colour and texture of a building against the sky, for example.

Every painting ought to display an individual style. How dull it would be if a classroom of students produced identical portraits of the same model! Each student must value his or her own distinctive way of interpreting the information that is taken in through the eye; and each student must look for the technique that best expresses that interpretation.

Search out portraits of children in galleries and museums and, as you look carefully at the painting, try to imagine yourself as the artist. Try to decide what has been emphasized and what has been left out of the portrait – for example, distinct colour variations in the hair that clarify the form; or detail omitted from the background that would have distracted the eye from subtleties in the skin colour. What do you think excited the artist – the colour and movement in the figure, or the gentleness or robustness in the expression?

As an aspiring painter of children you may wonder how best to find a sitter. The easiest way is to borrow the children of relatives or friends. Always go to the child's home, and encourage young children to continue with their games so that they will not feel threatened by your unaccustomed attention. Start with a child of medium age and calm temperament, who is likely to be responsive and interested in what you are doing. Or choose some quality – colouring, hair, expression – that appeals to you and that you find visually exciting.

You may find to begin with that you will learn more by painting the same child several times, if he or she is willing, than by tackling a new subject every time.

INDEX